FOUR THIRDS

& MICRO FOUR THIRDS

THE EXPANDED GUIDE

T0339158

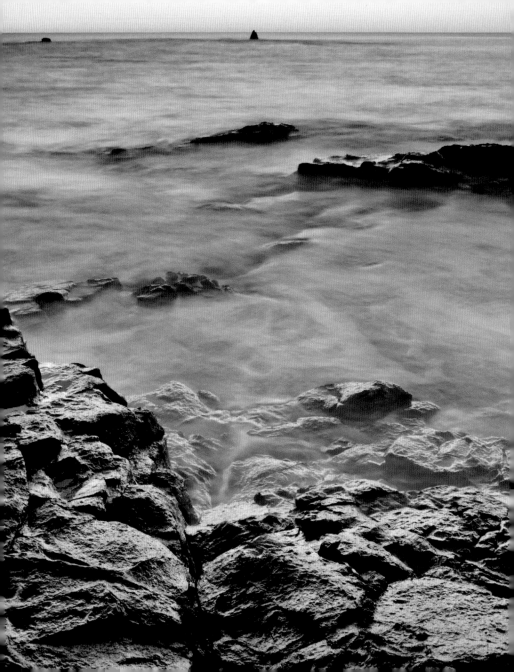

FOUR THIRDS
& MICRO FOUR THIRDS
THE EXPANDED GUIDE

David Taylor

AMMONITE
PRESS

First published 2011 by
Ammonite Press
an imprint of AE Publications Ltd
166 High Street, Lewes, East Sussex, BN7 1XU, UK

Text © AE Publications Ltd, 2011
Images © David Taylor, 2011, except:
© Olympus Imaging Corp. 8, 9, 10, 13, 14,19, 20, 26, 32, 34, 56, 59, 66, 69, 80, 81,
88, 89, 94, 95, 99, 104, 112, 118, 130, 131, 140, 142, 143 144, 145 162, 163, 178, 194,
195, 198, 199, 202
© Panasonic Corp. 17, 30, 39, 48, 74, 75, 98, 106, 107, 122, 123, 134, 135, 138, 142,
143, 148 149, 154, 168, 169, 172, 173, 184, 185, 188, 189
© Leica 49
© Copyright in the Work AE Publications Ltd, 2011

ISBN 978-1-90770-815-2

British Library Cataloging in Publication Data: A catalog record of this book is
available from the British Library.

Editor: Chris Gatcum
Series Editor: Richard Wiles
Design: Fineline Studios

Typeface: Giacomo
Color reproduction by GMC Reprographics
Printed and bound in China by Leo Paper Group

« PAGE 2
Pre-dawn on the
Northumbrian
coast, north-east
England.

» CONTENTS

Chapter 1
IN THE
BEGINNING

1 IN THE BEGINNING

On February 13, 2001, a press release was issued that began; "Eastman Kodak Company and Olympus Optical Company, Ltd. today announced a cross licensing agreement designed to expand the market for digital photography." It went on to explain that "Kodak and Olympus are working together to define and develop... high-resolution CCDs, which Kodak will manufacture and Olympus intends to purchase."

Although no further detail was given as to what products these CCD imaging sensors might be used in, the press release saw two of photography's long-established companies seemingly joining forces.

Kodak was founded in 1899 by George Eastman and needs little introduction. Its long history has seen it launch the iconic Box Brownie—which arguably made photography accessible to all—while an electrical engineer at Kodak, Steven Sasson, developed the first primitive digital camera in 1975. By 2001, developing digital technology for its own products, as well as for other camera manufacturers, was an increasingly important part of the Kodak business model.

Olympus is also a company with an illustrious past. Established in 1919, it initially manufactured microscopes and thermometers, but in 1936 introduced its first camera, the Semi-Olympus 1. Its biggest early success was its series of half-frame Pen cameras, the first of which was produced in 1959. In 1972 the company introduced its first OM SLR camera—the

OM-1—with the OM line culminating with the OM-4Ti, which stayed in production until as recently as 2002.

By 2001, however, the first digital SLRs were on the market, and Canon and Nikon had both produced interchangeable-lens

SEMI-OLYMPUS 1 ❯❯
The first Olympus camera to market.

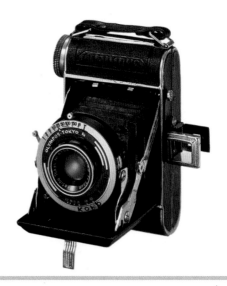

cameras that were based on their existing 35mm camera systems. While Olympus had experience in developing digital cameras (its Camedia series of digital compact cameras was well established), it did not have a digital interchangeable-lens camera available. Neither did it have a suitable 35mm model on which to base a digital SLR system: the OM cameras were never designed to have autofocus, which by 2001 was a "must-have" feature.

Therefore, the joint Kodak/Olympus press release was a sign that Olympus was planning something radical, and it wasn't long before rumors began to circulate about a new digital camera system that would make a clean break from Olympus's 35mm OM system.

The speculation finally ended in September 2002, with another joint press release announcing the Four Thirds system. By using a sensor that was smaller than a 35mm film frame and designing a new lens standard, Four Thirds cameras could be made smaller and lighter, with an image quality that would equal rival systems.

The concept behind the system was very simple: lenses developed for 35mm film-based cameras are not necessarily optimized to the needs of digital sensors, and are relatively large and cumbersome. Part of the problem is that a digital sensor is comprised of a grid of "pits" that catch light. If light does not shine straight down into each pit (which will form a pixel in the image), then the sensor will not receive enough information to make an adequate exposure in that area of the image. Light is more likely to strike the center of the sensor straight than at the edges, which

OLYMPUS OM-1 »
A much-loved 35mm
SLR from the 1970s.

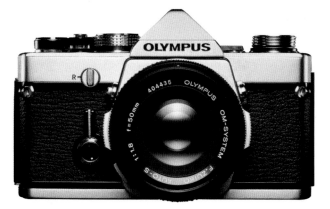

results in a darkening around the edges of the image. By developing a camera system from scratch, however, Four Thirds lenses could be optimized to the sensor, so all of the lenses could have a telecentric design, with light following a straight path, right to the edges of the sensor.

In addition to being developed from scratch, Four Thirds was also developed as an "open" system. This meant that as long as a manufacturer followed the specifications of the Four Thirds standard, they would be free to produce Four Thirds equipment without paying a licence fee.

The first Four Thirds camera to market was the professional grade Olympus E-1 in 2003, and since then, a further 16 Four Thirds cameras have been brought to market. By 2008, seven companies had agreed to support Four Thirds, with Fuji, Leica, Panasonic, Sanyo, and Sigma all signing up alongside the co-founders, Kodak and Olympus.

Of these companies, Leica, Olympus, and Panasonic have all produced cameras; Sigma has released a number of lenses; and Kodak has produced imaging sensors, as outlined in the original press release. The remaining two companies—Fuji and Sanyo—have not yet brought any product to the Four Thirds table.

In August 2008, Panasonic and Olympus announced a new system that would take the concept of size reduction further— Micro Four Thirds. This is not a replacement system, as Four Thirds is still supported. This was proven in September 2005 with the release of Olympus's impressive E-5.

OLYMPUS E-5 »
At the time of writing, the latest Four Thirds SLR camera.

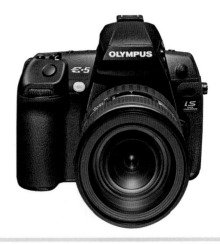

The Four Thirds standard

As Four Thirds is an "open" standard, there are certain key specifications that need to be followed by all manufacturers to guarantee full compatibility between camera bodies and lenses.

Sensor
Type 4/3-type image sensor
Size 21.63mm diagonal (see below)

Lens mount
Type Bayonet mount with a 70° attachment angle
Locking mechanism Lock groove on the lens-mount surface; locking pin engages after mounting
Electric contacts 9 contact points: fixed contact on the lens, movable contact on the body
Interface Lens information transmitted to camera for recording in image metadata

Four Thirds cameras to date

2003	Olympus E-1	2008	Olympus E-420
2004	Olympus Evolt E-300		Olympus E-520
2005	Olympus Evolt E-500		Olympus E-30
2006	Olympus Evolt E-330	2009	Olympus E-620
	Panasonic Lumix DMC-L1		Olympus E-450
	Leica Digilux 3	2010	Olympus E-5
	Olympus E-400		
2007	Olympus Evolt E-410		
	Olympus Evolt E-510		
	Panasonic Lumix DMC-L10		
	Olympus E-3		

Notes
- The Four Thirds sensor is not restricted to a specific shape or ratio, despite most Four Thirds cameras using a 17.3 x 13.0mm, 4:3 ratio sensor. Instead, it is defined by its diagonal measurement.
- The Four Thirds sensor is almost exactly half the size of a 35mm frame.
- Digital cameras based on the 35mm standard produce images with a 3:2 aspect ratio. This results in images that are a long rectangle in shape. In contrast, Four Thirds images can be squarer, similar to 6 x 7cm medium-format film.

ABSTRACTION ⌃

A photograph is often viewed as an objective record of
reality. However, the use of long shutter speeds can create
an abstract image that would be impossible to see by sight

» OLYMPUS E-1 September 2003

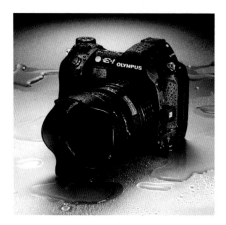

OLYMPUS E-1 ⪢
Olympus was rightly proud of its new
camera's capabilities in wet conditions.

The bold decision by the Four Thirds
consortium to design a camera system
specifically for digital image capture came
to fruition in the form of the Olympus E-1.
The process was not without its challenges,
and the use of a new lens mount left many
existing Olympus OM camera owners with
a dilemma: as well as purchasing a camera
body, there was also the need to invest in
a new set of lenses if they wanted to make
the move to a digital SLR, but remain loyal
to the Olympus brand.

This meant that the E-1 had several
jobs to do. It not only had to convince
professional and amateur photographers
alike that the new Four Thirds standard was

a viable prospect with a long-term future,
but it also had to tempt owners of OM
cameras to migrate to the new Olympus
digital format—ditching their existing lens
collection in the process—rather than
choosing a camera from Canon, Nikon,
or an alternative brand.

Awards
Olympus had to get the E-1 right and by
common consensus they managed to do
so: a year after its release, the E-1 had won
a clutch of awards. This was achieved in
part by concentrating on the ergonomics
of the camera, with intuitive controls and
a distinctively sculpted body that was easy
to hold in the hand.

The E-1's beauty wasn't just skin deep,
however, and the Supersonic Wave Filter
sensor dust-removal system was just one
unique feature at the time. The system
shakes dust from the sensor using high-
speed vibrations, and anyone who has
spent time cloning out dust spots from
their digital images will appreciate how
revolutionary this new technology was
in 2003.

Images
The sensor used in the E-1 was a
5-megapixel, full-frame transfer CCD.
There are two main systems used to create
digital sensors: CCD is one, CMOS the

other. In the early 2000s, CCDs were used more often by camera manufacturers, especially in digital SLR models, as they suffered less from image noise.

Once the sensor captures an image, it is processed before being written to the memory card, and the E-1 used Olympus's TruePic image processor for this task. Derivations of this processor remain in use today on cameras such as the E-5.

Robust

Another facet of the Olympus E-1 that still impresses is its robustness and overall build quality. With a magnesium alloy core, the E-1 stood up to all the abuse that a professional camera would encounter and was designed to be water resistant, with rubber gaskets between components to stop the ingress of water or dust. This did not mean that the E-1 could be taken underwater, but it did mean it would work after use in rain or in damp locations—a selling point that Olympus was quick to capitalize on.

A system camera

The E-1 would have been quickly dismissed without lenses, flashes, or any of the other ingredients of an expandable SLR photographic system, so it was released alongside a range of optional extras. This included a series of lenses covering the most popular focal length ranges (50mm and 300mm prime lenses, and 11–22mm, 14–54mm, and 50–200mm zooms), as well as the EC-14 teleconverter and EX-25 extension tube. The FL-50 flash was also released, which was an important addition, as in keeping with most cameras aimed at professional photographers, the E-1 did not have a built-in flash.

JARGON BUSTING: NOISE

Noise is seen as random spots of brightness or color in an image, and can reduce image quality by smothering fine detail. The amount of noise present in an image increases as the ISO is raised, or with long exposures. Noise can be reduced in-camera or during post-production, but overuse of noise-reduction tools can give an image an artificially smooth, "plastic" appearance.

OLYMPUS 14–54MM F/2.8–3.5 LENS ⌃
A fast, pro-spec zoom lens for the E-1.

› Olympus E-1 Specifications

Sensor
Resolution 5 megapixels (effective)
Type 4:3 aspect ratio CCD sensor

Image processor
TruePic

Body
Construction Materials Magnesium Alloy
Lens Mount Four Thirds

Image sizes
Maximum 2560 x 1920 pixels
Minimum 640 x 480 pixels

Storage media
CompactFlash (Type I & II); Micro Drive;
xD Picture Card (with an adapter)

File formats
JPEG (SHQ/HQ/SQ); TIFF; Raw (12-bit)

Focus
Type TTL Phase Difference Detection
Modes Single AF; Continuous AF;
Manual Focus
Focus Areas 3 points
Focus Selection Automatic; Manual
Detection Range EV0–19 (at ISO 100)
Depth of Field Preview Yes

Exposure
Metering Type TTL with 3-zone
multipattern system

Metering Modes Digital ESP;
Center-weighted; Spot (Approx. 2%)
Exposure Modes Programmed AE (**P**);
Aperture Priority (**A**); Shutter Priority (**S**);
Manual (**M**)
ISO Modes Auto/Manual
ISO Range 100–400 (Auto); 100–800,
expandable to 1600/3200 (Manual)
Exposure Compensation ±5EV in ⅓, ½,
or 1EV steps
Exposure Bracketing 3 or 5 frames in
±⅓, ½, or 1EV steps

Shutter
Type Electronically-controlled focal-plane
Shutter Speed 2 seconds–1/4000 sec. (**P**);
60 seconds–1/4000 sec. (**A** and **S**);
60 seconds–1/4000 sec., plus Bulb up to
8 minutes (**M**)

Viewfinder
Type Eye-level TTL Pentaprism
Coverage Approx. 100%
Magnification Approx. x0.96 (with 50mm
lens set to infinity)
Eyepoint 20mm
Diopter Adjustment -3 to +1

Drive system
Modes Single; Sequential Shooting
Max. Frame Rate 3.0 fps
Max. Frame Burst 12 frames
Self Timer 2 seconds; 12 seconds

Flash

Built-in Flash No
Modes Auto; Red-eye Reduction; Slow Sync; 2nd Curtain Slow Sync; Fill-in for Exclusive Flash
Sync Speed 1/180 sec.; 1/4000 sec. Super FP mode
Flash Exposure Compensation ±2EV in ⅓, ½, or 1EV steps

Playback monitor

Type Low Temperature Polysilicon TFT Color LCD
Dimensions 1.8in (4.6cm)
Resolution 134,000 pixels
Coverage 100%
Languages English; German; French; Spanish; Japanese; and Korean
Live View No

Connections

External Interfaces USB 2.0; Firewire
Video Out Jack Yes (NTSC or PAL)
Other Flash hotshoe; PC Flash Sync terminal; DC-in

Dimensions

Size 5.6 x 4.1 x 3.2in (141 x 104 x 81mm)
Weight 24oz (660g)

Included software

Olympus Viewer; Olympus Studio (trial)

Power

Rechargeable Li-ion battery pack BLM-1; Optional AC adapter

» CHOOSING A LENS

The type of photography that interests you will determine the lenses that will be most suitable for your needs. It is more than likely that your camera came with a kit lens when you bought it. Generally these lenses are zooms that offer a reasonable focal length range, from a modest wide-angle view at one end of the zoom range, to a respectable telephoto at the other. These lenses tend not to be the best of their type, though, and nor are they the most expansive, so you may eventually find them slightly limiting.

When the time comes to invest in a new lens, it is all too easy to be tempted by a particular lens, only to buy it and then rarely use it. The lens ranges available for both the Four Thirds and Micro Four Thirds systems are wide and complex, but the following pages will help you gain a greater understanding so you can make more informed purchasing decisions.

It is important to note that, as Four Thirds and Micro Four Thirds are "open" standards, lenses from one manufacturer can be used on the camera(s) from another.

LUMIX G VARIO HD 14–140mm ☆
1:4–5.8 ASPH MEGA O.I.S. LENS

Four Thirds lenses

There are currently three companies that make lenses for the Four Thirds system: Olympus, Panasonic, and Sigma.

Olympus uses the trade-name Zuiko to describe its lenses, continuing to use the name that first appeared on the Semi-Olympus 1 camera of 1936. The name is also derived from a Japanese word that can be translated as the "light of the gods," which is apt as, of course, Mount Olympus was the home of Zeus and other Ancient Greek deities.

Panasonic's Four Thirds lenses are designed by—and branded with—Leica AG, a German company renowned for the quality of its photographic products, with a history that stretches back to the 1920s.

Finally, Sigma, still makes three prime lenses for the system, despite discontinuing many of its Four Thirds optics.

Micro Four Thirds lenses

Both Olympus and Panasonic manufacture lenses for the Micro Four Thirds system, with Olympus using the Zuiko name, and Panasonic using its own name.

The Japanese company Cosina (using the Voigtländer name) has also announced support for the Micro Four Thirds system. At the time of writing only the manual focus Nokton 25mm prime lens is available, although more lenses have been promised.

It will also be interesting to see what Carl Zeiss AG and Schneider Kreuznach develop for the Micro Four Thirds market; both longstanding lens manufacturers signed up to the standard in early 2011.

› Lens terminology

Lenses for both the Four Thirds and Micro Four Thirds cameras employ technologies to help them to achieve the very best optical quality, and this is often represented by a bewildering array of abbreviations and acronyms in the names of the lenses. The following describes these features:

ASPH

Abbreviation of ASPHerical, this is a method of producing a lens to optimize contrast and sharpness across the entire image. This also helps to reduce the occurrence of color aberration.
Main benefit: Image quality is increased.

1

Circular aperture

The aperture of a lens is created by a number of blades that overlap to form a polygonal shape. Areas in an image that are out-of-focus take on this shape, which is particularly noticeable in highlight areas. The more blades an aperture has, the more circular these shapes become, leading to a more esthetically pleasing effect. The quality of a lens's out of focus areas is frequently referred to as its "bokeh."
Main benefit: Out-of-focus areas appear more natural.

DG

Sigma-specific term that refers to wide-angle, large maximum-aperture lenses with a short minimum focusing distance.
Main benefit: Large maximum aperture.

CHROMATIC ABERRATION ⌄
Red/green chromatic aberration is noticeable in this image where the two highly contrasting tones meet.

EX

Simply stands for "EXcellent," and is Sigma's method of branding its top-of-the-range lenses that it feels are outstanding in design, optics, and mechanics.
Main benefit: A lot or none, depending on how you view Sigma's marketing.

Extra-low dispersion glass

Chromatic aberration is the inability of a lens to focus the various wavelengths that make up visible light at the same point. This results in colored fringing—typically red and green—that is noticeable most often in the corners of images. Extra-low dispersion (ED) glass helps reduce the occurrence of chromatic aberration.
Main benefit: Improved image quality compared to conventional glass elements.

Fisheye

A fisheye refers to a lens with an extremely wide angle of view, usually 180°. This results in an extreme distortion of perspective, where straight lines appear curved and distance is exaggerated. The fisheye look is one that people either love or hate, and it needs to be used sparingly if you want to avoid your images looking repetitive.
Main benefit: Creates an unusual and distinctive view of the world.

Focus range limiter

This feature is usually found only on macro lenses and forces the lens to autofocus across a narrow band of the full focus range. This stops the lens "hunting" across the macro range unnecessarily when you are shooting subjects at "normal" distances.
Main benefit: Speeds up autofocus.

Hypersonic Motor/Supersonic Wave Drive

A Hypersonic Motor (HSM) and Supersonic Wave Drive (SWD) use ultrasonic waves to drive the autofocus mechanism of the lens, which is a fast, silent, and precise method of moving the focusing elements, and one that is superior to older mechanical systems. Another benefit of HSM and SWD focusing is that the focus can often be overridden manually without disengaging autofocus first.
Main benefit: Helps to speed up various autofocus operations.

M.Zuiko

Denotes an Olympus lens designed for the Micro Four Thirds system only.
Main benefit: Often smaller and lighter than a Four Thirds equivalent.

Macro

A macro lens is defined as one that creates an image on the sensor that is the same size, or greater, than the subject that is focused on. This is referred to as a 1:1

PANCAKE LENS ⌃
Olympus E-P2 with a 17mm "pancake" lens.

reproduction ratio or as 1x magnification.
Main benefit: Extreme close-up photographs are possible.

MEGA O.I.S.

Short for "Mega Optical Image Stabilization," Panasonic's lens-based image-stabilization system that adjusts a group of lens elements to compensate for movement.
Main benefit: Reduces the risk of camera shake due to slow shutter speeds.

Pancake lens

A lens described as a "pancake" is one that has a very short physical length. This is achieved by certain compromises being made in the optical quality in comparison to a conventional, and therefore larger, lens of the same focal length. However, depending on your style of photography, the small size and weight of a pancake lens may well be worth those compromises.
Main benefit: Small size and weight.

1 » OLYMPUS EVOLT E-300 December 2004

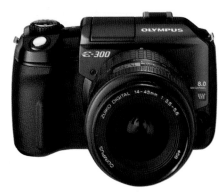

OLYMPUS E-300 ⌃
The distinctive shape of the E-300, shown here
with a Zuiko 14-45mm f/3.5-5.6 kit lens.

Like many camera manufacturers, the
naming convention Olympus uses for
its cameras signifies where a model sits
in the manufacturer's line-up. Olympus's
professional cameras make do with one
digit, such as the E-1, while the needs of
the "prosumer"—a diverse group of
people that includes professionals and
enthusiasts—are met by cameras with
two digits (as in the Olympus E-30).

The least expensive consumer models
sport three digit model numbers and, as
a further refinement, the higher the first
digit, generally the better specified the
camera. This means that the Olympus Evolt
E-300 ("Evolt" appears in the model name
in North America, but not in Europe) was
aimed squarely at the consumer market.

Innovation

You might think that Olympus would
have been conservative with the design
for its first mass-market camera, but, rather
boldly, the company decided to defy
convention with the E-300. Even today,
the most striking feature of the E-300 is the
lack of a "hump" for a pentaprism as seen
on most digital SLRs. Instead, the E-300
uses an optical Porro mirror system to send
the image from the lens to the viewfinder.
The advantage of this viewing method is
a reduction in weight over a conventional
pentaprism. The square shape helped
the E-300 to stand out visually from its

JARGON BUSTING: OPTICAL VIEWFINDER

A conventional digital SLR camera uses
a mirror to direct light coming through
the lens to a pentaprism (a five-sided
prism) in the top of the camera, and
from there to the camera viewfinder.
When a lens creates an image, it is
inverted, so the pentaprism re-inverts
it so that what you see through the
viewfinder is in the correct orientation.
A Porro mirror system, as the name
suggests, uses a series of mirrors to
achieve the same result.

competitors, although it did make the camera look rather similar in design to compact digital cameras, albeit on a larger scale. This impression was enhanced by the fact that the viewfinder was offset to the left side of the camera, rather than being located centrally—another "benefit" of using such an unconventional design.

Sensor

The E-300's sensor had an 8-megapixel resolution—a significant increase from the 5-megapixel sensor in the E-1—but it retained the Supersonic Wave Filter that was used to reduce the occurrence of dust on the sensor.

The E-300's CCD sensor was a full-frame transfer device manufactured by Kodak. The advantage of this type of CCD is that a greater area of the sensor is available for light capture, resulting in improved image detail and decreased noise. To cope with the data coming from the sensor, the E-300 used Olympus's TruePic TURBO image processor, a derivation of the type used in the E-1.

Flash

Unlike the E-1, the consumer-orientated E-300 had a retractable flash unit, although in keeping with all flashes of this type, it was far from powerful. However, despite a lack of power, the flash was useful for fill-in purposes, and doubled as an autofocus assist lamp when light levels were low.

Memory cards

Unusually for a camera aimed at the consumer market, the E-300 was able to use both CompactFlash and xD memory cards (in conjunction with a MACF-10 adapter). CompactFlash is still very much in use today, but xD is not: although Olympus persisted with xD for a number of years, the release of the SD-only E-P1 in 2009 confirmed that xD has had its day, and it has now been superseded by the SD memory card format.

MEMORY CARDS »
xD memory cards (right) have been superseded by the SD family of memory cards (far right).

› Olympus Evolt E-300 Specifications

Sensor
Resolution 8 megapixels (effective)
Type 4:3 aspect ratio CCD sensor

Image processor
TruePic TURBO

Body
Construction Materials Aluminum chassis;
Aluminum and plastic covering
Lens Mount Four Thirds

Image sizes
Maximum 3264 x 2448 pixels
Minimum 1024 x 768 pixels

Storage media
CompactFlash (Types I & II); Micro Drive;
xD Picture Card if used with CF card
adapter MACF-10

File formats
JPEG (SHQ/HQ/SQ); TIFF; Raw (12-bit)

Focus
Type TTL Phase Difference Detection
Modes Single AF; Continuous AF; Manual
Focus; Focus Tracking (in Continuous AF)
Focus Areas 3 points
Focus Selection Automatic; Manual
Detection Range EV0–19 (at ISO 100)
Depth of Field Preview Yes

Exposure
Metering Type TTL with 3-zone
multipattern system
Metering Modes Digital ESP; Center-
weighted; Spot (Approx. 2%)
Exposure Modes Programmed AE (**P**);
Aperture Priority (**A**); Shutter Priority (**S**);
Manual (**M**)
Scene Program Portrait; Macro;
Landscape; Night Scene; Sports
Scene Select Portrait; Macro; Landscape;
Night Scene; Sports; Landscape with
Portrait; Night Scene with Portrait;
Fireworks; Sunset; High Key; Document;
Museum; Beach & Snow; Candle
ISO Modes Auto/Manual
ISO Range 100–400 (Auto); 100–400,
expandable to 1600 (Manual)
Exposure Compensation ±5EV in ⅓, ½, or
1EV steps
Exposure Bracketing 3 frames in ±⅓, ½, or
1EV steps

Shutter
Type Electronically-controlled focal-plane
Shutter Speed 1 second–1/4000 sec. (**P**);
30 seconds–1/4000 sec. (**A** and **S**);
30 seconds–1/4000 sec., plus Bulb up to
8 minutes (**M**); 4 seconds–1/4000 sec.
(Scene Program and Scene Select)

Viewfinder

Type Eye-level TTL Optical Porro mirror
Coverage Approx. 94%
Magnification Approx. x1.0 (with 50mm
lens set to infinity)
Eyepoint Approx. 20mm at -1 diopters
Diopter Adjustment -3.0 to +1

Drive system

Modes Single; Sequential Shooting
Max. Frame Rate 2.5 fps
Max. Frame Burst 4 frames (Raw/TIFF);
Resolution and compression ratio
dependent (JPEG HQ/SQ)
Self Timer 2 seconds; 12 seconds

Flash

Built-in Flash Yes
Guide Number 42ft/13m @ ISO 100
Modes Auto; Red-eye Reduction; Slow
Sync; 2nd Curtain Slow Sync; Fill-in for
Exclusive Flash
Sync Speed 1/180 sec.; 1/4000 sec. Super
FP mode
Flash Exposure Compensation ±2EV in
⅓, ½, or 1EV steps
Other Information Multi-flash control

Playback monitor

Type HyperCrystal LCD (color TFT)
Dimensions 1.8in (4.6cm)
Resolution 134,000 pixels
Coverage 100%
Languages English; German; Spanish;
French; Option of downloading one
further language from the Internet
Live View No

Connections

External Interfaces USB 1.1
Video Out Jack Yes (NTSC or PAL
selectable)
Other Flash hotshoe; Optional IR
remote control; DC-in

Dimensions

Size 5.8 x 3.4 x 2.5in (147 x 85 x 64mm)
Weight 1.3lb (580g)

Included software

Olympus Master

Power

Rechargeable Li-ion battery pack BLM-1;
Optional AC adapter

Focal length

The focal length of a lens is a measurement—in millimeters—from the optical center of the lens to the point where a subject at infinity is in focus. This point is known as the focal plane, and is where the sensor is positioned. Some cameras have this point marked on the exterior with a ⊖ symbol.

The focal length of a lens never changes, regardless of what camera it is mounted on. A lens with a fixed focal length is referred to as a prime lens, while a lens that contains a variety of focal lengths is known as a zoom lens.

Angle of view

The Four Thirds sensor is half the size of a 35mm or "full-frame" sensor, which has a big impact on the angle of view of lenses. The angle of view (also known as the field of view) of a lens is a measure of how much of a scene, measured in degrees, is projected by the lens onto the digital sensor. The angle of view figure can refer to either the horizontal, vertical, or diagonal coverage of the lens, and if there is only one figure given (which is common) it will refer to the diagonal angle of view.

The angle of view is dependent on the physical size of the sensor onto which the image is projected. Because the Four Thirds sensor is half the size of a full-frame

sensor, the angle of view of a lens is also halved when comparing the two systems. Therefore, a 50mm lens on a full-frame camera has a (diagonal) angle of view of

ROCK FORMATION ❯❯
This photo was shot with a "full-frame" camera using a 28mm focal length. If I had been able to use the same lens on a Four Thirds camera, the angle of view would have been reduced and I would only have been able to record the area within the red box. Therefore, to achieve the same angle of view on a Four Thirds camera, I would have needed to use a 14mm focal length.

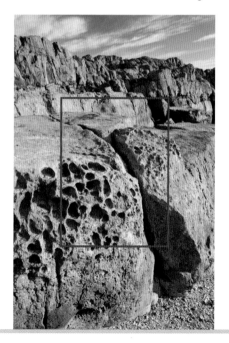

47°, but the angle of view will only be 24° on a Four Thirds system. The difference is not precisely half, but for the sake of simplicity it is close enough to make no practical difference.

Crop factor

The "crop factor" is a figure that allows you to calculate easily the difference in the angle of view of a lens if you were able to use it on both a full-frame (35mm) SLR and a Four Thirds camera. The crop factor of the Four Thirds system is 2x compared to a camera with a full-frame sensor.

What this means in practical terms is that you need to use a shorter focal length on a Four Thirds camera to achieve the same angle of view that you would achieve with a full-frame camera. A 14mm lens is required to achieve the same angle of view as a 28mm lens used on a full-frame camera, for example.

However, the wider lens will invariably show more distortion than its full-frame equivalent. This is because it is more difficult to create wide-angle lenses, as the shorter the focal length, the more distortion becomes a problem (a fisheye lens with its high levels of distortion is an extreme example of this effect). As a result, ultra-wide lenses need to be well designed, and manufactured with the very best glass, which has obvious cost implications.

It is not all bad news with wide-angles though: the shorter the focal length of a lens, the greater the inherent depth of field. This means it is easier to achieve front-to-back sharpness with a Four Thirds lens than using lenses with an equivalent angle of view on a full-frame camera.

The crop factor is far more useful with long lenses—a 150mm focal length on a Four Thirds camera has the same angle of view as a 300mm lens on a full-frame camera, for example, but without the size, weight, or associated cost.

JARGON BUSTING: DISTORTION

Distortion is seen most often when shooting architectural subjects when supposedly straight lines appear bent. There are two main types of distortion: pin-cushion and barrel. Pin-cushion distortion is apparent when straight lines appear to bow in toward the center of an image, and barrel distortion is evident when they bow outward. Zoom lenses typically suffer from barrel distortion at one end of the focal length range, and pin-cushion at the other.

1 » OLYMPUS EVOLT E-500 September 2005

OLYMPUS E-500 ⌃
With a Zuiko 14–45mm f/3.5–5.6 kit lens.

The Olympus E-500 was more conventional in its appearance than the E-300, and was aimed at a market segment somewhere between the professional E-1 and the entry-level E-300. It therefore had a greater range of features than the E-300, but lacked the rugged build of the E-1.

Sensor

The CCD sensor inside the E-500 matched the resolution of the one found in the E-300, at 8 million pixels, and it also retained the same TruePic TURBO image processor. The image buffer in the E-500 was 64Mb, allowing the shooting of up to four TIFF or Raw files at 2.5 frames per second, while speed shooters could record an unlimited number of JPEGs at a high quality setting—at least unlimited until the memory card was full.

Metering

Inside the E-500 was a new 49-area exposure sensor that allowed the exposure algorithms used previously for the ESP exposure system to be upgraded and refined. The more conventional center-weighted average and spot-metering exposure modes were also included and, unique to Olympus, highlight and shadow spot-metering options made an appearance. These are powerful tools when used correctly, and it remains a mystery why other camera manufacturers don't provide something similar.

To make use of the metering system, photographers could choose from the standard Program, Aperture Priority, Shutter Priority, and Manual settings, as well as 21 different scene modes. These included Portrait, Landscape and, rather

JARGON BUSTING: SCENE MODES

A scene mode designed to be used in a specific photographic situation. Camera settings, such as shutter speed and aperture are optimized to help you achieve a satisfactory result. Typical scene modes are Portrait and Landscape. One drawback with scene modes is that you are often unable to change all but the very basic settings on the camera.

oddly, a Document mode, presumably for people who often photograph documents.

LCD

The E-500 had a 2.5-inch, 215,000 pixel HyperCrystal LCD that promised better contrast than most designs of the time and all the camera settings (with the exception of the mode dial) were viewed either on the LCD or through the viewfinder. As is common now, the E-500 did not have an LCD on the top plate, and relied on dedicated buttons to alter settings. This made the rear of the camera look busy, but made it easier to set options without wading through numerous menu screens. There were eight direct buttons for settings such as white balance and AF mode, with the options changed by pressing a button and then using a well-placed thumb-dial to make an adjustment.

Flash

The E-500's built-in flash was housed in the pentaprism "hump" above the lens and, because of the height of the pentaprism, the flash actually stood quite high over the camera when raised. This helped with flash operation in a number of ways, as it reduced the risk of "red-eye" and avoided casting a shadow when a lens hood or filter system was attached to the front of the lens. In certain modes the camera

would automatically raise the flash, or, in low-light, it could be raised manually to provide an AF-assist lamp.

Lenses

At the same time as the E-500 was announced, Olympus also revealed two more Zuiko zoom lenses. The first was a 17.5–45mm f/3.5–5.6 zoom lens (which has since been removed from the range), while the second was an 18–180mm f/3.5–6.3 zoom lens that remains in production.

PORTRAIT ⌄
Scene modes, such as Portrait (used here), are ideal when you want to create good photographs without worrying too much about the technicalities.

› Olympus Evolt E-500 Specifications

Sensor

Resolution 8 megapixels (effective)
Type 4:3 aspect ratio CCD sensor; 17.3mm x 13.0mm effective area

Image processor

TruePic TURBO

Body

Construction Materials Fiber-reinforced polycarbonate
Lens Mount Four Thirds

Image sizes

Maximum 3264 x 2448 pixels
Minimum 640 x 480 pixels

Storage media

CompactFlash (Types I & II); Micro Drive; xD Picture Card (Dual Slot)

File formats

JPEG (SHQ/HQ/SQ); TIFF; Raw (12-bit)

Focus

Type TTL Phase Difference Detection
Modes Single AF; Continuous AF; Manual Focus; Focus Tracking (Continuous AF)
Focus Areas 3 points
Focus Selection Automatic; Manual
Detection Range EV0–19 (at ISO 100)
Depth of Field Preview Yes

Exposure

Metering Type TTL with 49-zone multipattern system
Metering Modes Digital ESP; Center-weighted; Spot (Approx. 2%); Spot with highlight and shadow control
Exposure Modes Full Auto; Programmed AE (**P**); Aperture Priority (**A**); Shutter Priority (**S**); Manual (**M**); Scene Program AE; Scene Select AE
Scene Program Portrait; Landscape; Macro; Sports; Night Scene with Portrait
Scene Select Portrait; Landscape; Landscape with Portrait; Night Scene; Night Scene with Portrait; Firework; Sunset; Macro; Sports; High Key; Low key; Document; Beach & Snow; Candle; Children
ISO Modes Auto/Manual
ISO Range 100–400 (Auto); 100–400, expandable up to 1600 (Manual)
Exposure Compensation ±5EV in ⅓, ½, or 1EV steps
Exposure Bracketing 3 frames in ±⅓, ½, or 1EV steps

Shutter

Type Electronically-controlled focal-plane
Shutter Speed 60 seconds–1/4000 sec. (**P** and **A**; condition dependent); 60 seconds–1/4000 sec. (**S**); 60 seconds–1/4000 sec., plus Bulb up to 8 minutes (**M**); 2 seconds–1/4000 sec. (Full Auto); 2 seconds–1/4000 sec. (Scene Mode)

Viewfinder
Type Eye-level TTL Optical Penta Dach mirror type
Coverage Approx. 95%
Magnification Approx. x0.9 (with 50mm lens set to infinity)
Eyepoint Approx. 16mm at -1 diopter
Diopter Adjustment -3.0 to +1

Drive system
Modes Single; Sequential Shooting
Max. Frame Rate 2.5 fps
Max. Frame Burst 4 frames (Raw/TIFF); Up to card capacity (JPEG HQ/SQ)
Self Timer 2 seconds; 12 seconds

Flash
Built-in Flash Yes
Guide Number 42ft/13m @ ISO 100
Modes Auto; Red-eye Reduction; Slow Sync; Fill-in for Exclusive Flash
Sync Speed 1/180 sec.; 1/4000 sec. Super FP mode
Flash Exposure Compensation ±2EV in ⅓, ½, or 1EV steps
Other Information 1st and 2nd curtain selectable; Multi Flash Control; AF Assist when flash is raised

Playback monitor
Type HyperCrystal LCD (color TFT)
Dimensions 2.5in (6.35cm)
Resolution 215,250 pixels
Coverage 100%

Languages English; German; French; Spanish; Japanese; Chinese; Korean (region dependent)
Live View No

Connections
External Interfaces USB 2.0
Video Out Jack Yes (NTSC or PAL)
Other Flash hotshoe

Dimensions
Size 5 x 3.7 x 2.6in (129.5 x 94.5 x 66mm)
Weight 15.34oz (435g)

Included software
Olympus Master

Power
Rechargeable Li-ion battery pack BLM-1; 3x CR123A with LBH-1 adapter; Internal battery for date and time saving

1 » PRIME LENSES

A prime lens has a fixed focal length, and there are currently nine such lenses produced for the Four Thirds system, and seven for Micro Four Thirds (see the lens charts on pages 40–43). In the past, prime lenses were significantly superior in terms of their optical quality to zoom lenses, but modern lens design has eroded that advantage somewhat.

At first glance, it may now be hard to see the appeal of a prime lens compared to a zoom lens that offers a range of focal lengths, but a prime lens still has the upper hand in terms of its maximum aperture. To avoid added weight and cost, zoom lenses typically have small maximum apertures (of f/4 or f/5.6, for example), which limits their light-gathering ability. You therefore have to rely on increasing the camera's ISO to maintain a sufficiently fast shutter speed to avoid camera shake when the light levels are low. This inevitably degrades the quality of your images, and should be avoided if at all possible.

With prime lenses, it is less of a problem, as they generally have wider maximum apertures. Voigtländer's Nokton 25mm prime lens for the Micro Four Thirds system has a maximum aperture of f/0.95, for example, which would allow you to maintain a reasonably fast shutter speed in very low lighting conditions, without increasing the ISO to its maximum setting.

PANASONIC LUMIX G 8MM FISHEYE LENS ⌃

Selective focus

When we view a photograph, our eyes tend to be drawn toward the areas of greatest sharpness, ignoring areas that are soft and out of focus. This can be exploited by employing selective focus techniques that combine precise focusing with the widest aperture possible, to create the minimum amount of depth of field. For this reason, the technique is more effective with a prime lens than with a zoom.

Where you focus is entirely up to you, but as it will be the most important part of the scene, you should consider carefully what this is. If you use autofocus, you may need to move the focus point around in the viewfinder. This technique is often easier to achieve with Live View as the positioning of the AF point is often more

flexible. You will also be able to magnify the image and check that the focus is correct before you make the photograph.

Once the focus point is set, the lens should be set to its widest aperture. In Program (**P**) this can be achieved by using Program Shift (if available), otherwise you can use Aperture Priority (**A**) or Manual (**M**) mode to control the aperture.

> ### *Tip*
>
> *The longer the lens, the shallower the depth of field. Try using a long, prime lens for maximum effect.*

GERBERAS ⌄
Selective focusing helps to simplify a picture. By shooting this photograph with the lens set to f/5, the depth of field is so small that the background is out of focus, and therefore less of a distraction.

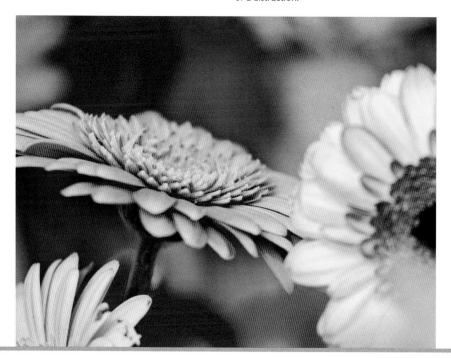

1 » ZOOM LENSES

A "zoom" is a lens that allows the focal length to be altered. Most Four Thirds and Micro Four Thirds cameras come with a kit lens and, with the exception of the occasional pancake lens, this tends to be a zoom.

The biggest advantage of a zoom lens is that often you don't need many more lenses to cover your photographic needs. The Leica D Vario-Elmar 14–150mm, for example, is equivalent to a 28–300mm "full-frame" lens. Essentially this offers wide angle to respectably long telephoto focal lengths in one package, and to buy an equivalent spread of prime lenses would be exorbitantly expensive.

This also makes zooms easier to use as "everyday" lenses. When working with prime lenses, particularly in fast-moving situations, it is all too easy to have the "wrong" lens fitted to your camera and so miss a shot, but with a zoom you simply have to adjust the focal length.

There are currently 16 zoom lenses available in the Four Thirds mount and 12 designed for the Micro Four Thirds standard. With the use of an adapter it is possible to use all Four Thirds lenses (both zooms and prime lenses) on Micro Four Thirds cameras, although the autofocus may be slower than expected.

ZUIKO LENSES ❯❯
A selection of Olympus's Four Thirds lenses.

SAN FRANCISCO »
A zoom lens with a good focal length range is invaluable when you are out exploring a city for the day.

Settings
> Focal length: 98mm
> Aperture: f/8
> Shutter speed: 1/640 sec.
> ISO 200

1 » OLYMPUS EVOLT E-330 January 2006

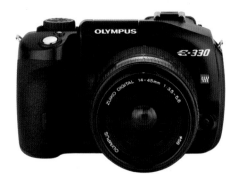

OLYMPUS E-330 ⌄
With a Zuiko 14–45mm f/3.5–5.6 "kit" lens.

Although on the surface it appears to be an evolution of the E-300, the E-330 was a revolutionary camera in its own right, as it was the first digital SLR camera in the world to feature full-time Live View, a feature that is now taken for granted and has enabled digital SLRs to record movies.

Live View

As with the E-300, the E-330 used an optical Porro mirror system to direct light to the viewfinder. This made it possible to fit a second, smaller CCD image sensor within the viewfinder's optical path, which was not used to create the final photo and only showed 92% of the frame. However, as a result, the E-330 could have two Live View modes: Mode A and Mode B.

Mode A used the small, secondary CCD sensor to feed the image received directly to the LCD screen on the rear of the camera. This meant that the reflex mirror could stay in position and full autofocus was still possible.

Alternatively, Mode B used the main Live MOS imaging sensor. This meant that the mirror assembly had to be raised, so AF was no longer possible, but 100% of the image was displayed on the rear LCD and, as the image could be magnified, it made it easier to achieve critical focus when focusing manually. A later firmware update allowed AF in Live View Mode B, but this interrupted Live View by raising the mirror briefly to focus.

Both modes were able to show shooting information and compositional guides over the live image. Some of the compositional guides are now standard, such as the useful grid line function, but some have fallen out of favor, such as the portrait guide that displayed an outline of a head to suggest where you should place your subject.

LCD

As with the E-500 before it, the E-330 used a 2.5-inch HyperCrystal LCD, although the E-330's screen was hinged and could be pulled out from the camera body. It could

not be swung out from the camera as modern systems can be, but it was still useful, particularly to macro photographers wanting to make full use of Live View.

Black and white

An option on the E-330 that was of interest to black and white photographers was the ability to apply color filters to an image when shooting in monochrome. One of the big problems of shooting in black and white is tonal separation: red, green, and blue of a similar density look completely different in color, but when converted to black and white, each will be the same shade of gray. Colored filters block light that is on the opposite side of a standard color wheel to the color of the filter, so a red filter blocks blue light, for example, making anything blue much darker, while anything red appears much lighter.

The inclusion of black-and-white filters in the E-330 was proof that Olympus seemed to be designing its cameras with the user very much in mind.

BLACK AND WHITE ⌄
Left: A full-color photograph.
Center: A "straight" black-and-white shot, without any filters.
Right: Photographed in black and white, with a red filter.

Sensor

Resolution 7.5 megapixels (effective)
Type 4:3 aspect ratio Live MOS sensor

Image processor

TruePic TURBO

Body

Construction Materials Plastics
Lens Mount Four Thirds

Image sizes

Maximum 3136 x 2352 pixels
Minimum 640 x 480 pixels

Storage media

CompactFlash (Types I & II); Micro Drive;
xD Picture Card (Dual Slot)

File formats

JPEG (SHQ/HQ/SQ); TIFF; Raw (12-bit)

Focus

Type TTL Phase Difference Detection
Modes Single AF; Continuous AF; Manual
Focus; Single AF + MF; Continuous AF +
MF; Focus Tracking (Continuous AF mode)
Focus Areas 3 points
Focus Selection Automatic; Manual
Detection Range EV0-19 (at ISO 100)
Depth of Field Preview Yes (using optical
viewfinder and LCD monitor)

Exposure

Metering Type TTL with 49-zone
multipattern system
Metering Modes Digital ESP; Center-
weighted; Spot (Approx. 2%; Highlight
Spot; Shadow Spot
Exposure Modes Programmed AE (**P**);
Aperture Priority (**A**); Shutter Priority (**S**);
Manual (**M**)
Scene Program Portrait; Landscape;
Macro; Sports; Night Scene with Portrait
Scene Modes Portrait; Landscape;
Landscape with Portrait; Night Scene;
Night Scene with Portrait; Firework;
Sunset; Macro; Nature Macro; Sports; High
Key; Low Key; Document; Beach & Snow;
Panorama (requires special xD card);
Candle; Children; Image Stabilizer (ISO
boost); Underwater macro; Underwater
wide (when underwater housing fitted)
ISO Modes Auto/Manual
ISO Range 100–400 (Auto); 100–400,
expandable up to 1600 (Manual)
Exposure Compensation ±5EV in ⅓, ½,
or 1EV steps
Exposure Bracketing 3 frames in ±⅓, ½,
or 1EV steps

Shutter

Type Electronically-controlled focal-plane
Shutter Speed 2 seconds–1/4000 sec.
(**P** and **A** modes; condition dependent);
60 seconds–1/4000 sec. (**S**); 60 seconds–
1/4000 sec., plus Bulb (**M**);
4 seconds–1/4000 sec. (Scene Mode)

Viewfinder

Type Eye-level TTL Optical Porro mirror
Coverage Approx. 95%
Magnification Approx. x0.93 (with 50mm lens set to infinity)
Eyepoint Approx. 18mm at -1 diopter
Diopter Adjustment -3.0 to +1

Drive system

Modes Single; Sequential Shooting
Max. Frame Rate 3 fps
Max. Frame Burst 4 frames (Raw/TIFF); Minimum 15 frames (JPEG HQ/SQ)
Self Timer 2 seconds; 12 seconds

Flash

Built-in Flash Yes
Guide Number 43ft/13m @ ISO 100
Modes Auto; Red-eye Reduction; Slow Sync; Slow Sync with Red-eye Reduction; 2nd Curtain Slow Sync; Fill-in
Sync Speed 1/180 sec.; 1/4000 sec. Super FP mode
Flash Exposure Compensation ±2EV in ⅓, ½, or 1EV steps

Playback monitor

Type HyperCrystal LCD (color TFT)
Dimensions 2.5in (6.35cm)
Resolution 215,250 pixels
Coverage 100%
Languages English; German; Spanish; French; Italian; Russian; One of the following can be downloaded via the -Internet: Portuguese; Dutch; Czech; Danish; Norwegian; Swedish
Live View Mode A: Full-time live preview with AF (92% frame coverage); Mode B: Macro live view with MF (100% frame coverage); both modes up to 10x magnification

Connections

External Interfaces USB 2.0
Video Out Jack Yes (NTSC or PAL)
Other Flash hotshoe; Optional IR remote control

Dimensions

Size 5.5 x 3.4 x 2.8in (140 x 87 x 72mm)
Weight 1.2lb (539g)

Included software

Olympus Master

Battery

Rechargeable Li-ion battery pack BLM-1; 3x CR123A with LBH-1 adapter

1 » MICRO FOUR THIRDS LENSES

When the Micro Four Thirds standard was announced, the most striking aspect of the press release was the fact that the lens mount would be different to that used on the currently available Four Thirds cameras. Although the two lens ranges are almost on a par with each other now, it did mean that initially there was a limited lens line-up for the new system.

However, the use of an adapter meant that a Four Thirds lens could be fitted to a Micro Four Thirds camera. The differences in the focusing mechanisms between the two systems resulted in some autofocus functionality being restricted on some camera and lens combinations, but, the use of an adapter was—and still is—a way to share lenses if you use both systems.

That's not the end of the story, though. The width of the Micro Four Thirds lens mount is far smaller than the lens mounts of other camera systems, so it is possible to use an adapter to fit lenses from other camera systems as well. Olympus now sell an adapter that enables you to use manual OM lenses if you so wish, while third-party manufacturers produce adapters that allow you to fit lenses made by Pentax and Nikon to your Micro Four Thirds camera body.

Three dimensions
Unique to Micro Four Thirds is the Lumix G 12.5mm 3D lens (H-FT012). The lens is a prime lens with a fixed aperture, which produces two side-by-side images, roughly equivalent to the distance between our

LENS ADAPTERS

Make/Model	Function
Panasonic DMW-MA1	Four Thirds to Micro Four Thirds
Panasonic DMW-MA2M	Leica M series to Micro Four Thirds
Panasonic DMW-MA3R	Leica R series to Micro Four Thirds
Olympus MMF-1 & 2	Four Thirds to Micro Four Thirds
Olympus MF-2	Olympus OM to Micro Four Thirds

own eyes. When the camera's memory card is connected to Panasonic Viera 3DTV, the two images are combined to produce a 3D effect when it is viewed through the television's specialist eyewear.

This technology is currently only compatible with more recent Panasonic cameras, but it does show the potential for 3D still image capture in the future.

LENS ADAPTERS »

Top: PANASONIC MA1
(Four thirds to Micro Four Thirds)

Center: PANASONIC MA2M
(Leica M to Micro Four Thirds)

Bottom: PANASONIC MA3R
(Leica R to Micro Four Thirds)

1 » FOUR THIRDS LENS CHART

Lens Name	Aperture range	Number of aperture blades	Focus range (meters)
Zuiko ED 7-14mm 1:4.0	f/4-f/22	7	0.25-∞
Zuiko ED 8mm 1:3.5 Fisheye	f/3.5-f/22	7	0.135-∞
Zuiko 9-18mm 1:4.0-5.6	f/4-f/22	7	0.25-∞
Zuiko 11-22mm 1:2.8-3.5	f/2.8-f/22	7	0.28-∞
Zuiko ED 12-60mm 1:2.8-4.0 SWD	f/2.8-f/22	7	0.25-∞
Zuiko ED 14-35mm 1:2.0 SWD	f/2-f/22	9	0.35-∞
Zuiko ED 14-42mm 1:3.5-5.6	f/3.5-f/22	7	0.25-∞
Leica D Vario-Elmar 14-50mm 1:3.8-5.6 MEGA O.I.S.	f/3.8-f/22	7	0.29-∞
Leica D Vario-Elmar 14-50mm 1:2.8-3.5 MEGA O.I.S.	f/2.8-f/22	7	0.29-∞
Zuiko 14-54mm 1:2.8-3.5 II	f/2.8-f/22	7	0.22-∞
Leica D Vario-Elmar 14-150mm 1:3.5-5.6 MEGA O.I.S.	f/3.5-f/22	7	0.5-∞
Zuiko ED 18-180mm 1:3.5-6.3	f/3.5-f22	7	0.45-∞
Zuiko 25mm 1:2.8 Pancake	f/2.8-f22	7	0.2-∞
Leica D Summilux 25mm 1:1.4 ASPH	f/1.4-f/16	7	0.38-∞
Sigma 30mm 1:1.4 EX DC / HSM	f/1.4-f/16	8	0.4-∞
Zuiko 35mm 1:3.5 Macro	f/3.5-f/22	7	0.146-∞
Zuiko ED 35-100mm 1:2.0	f/2-f/22	9	1.4-∞
Zuiko ED 40-150mm 1:4.0-5.6	f/4-f/22	7	0.9-∞
Zuiko ED 50-200mm 1:2.8-3.5 SWD	f/2.8-f/22	9	1.2-∞
Zuiko ED 50mm 1:2.0 Macro	f/2.0-f/22	7	0.24-∞
Sigma 50mm 1:1.4 EX DG HSM	f/1.4-f/16	9	0.45-∞
Zuiko ED 70-300mm 1:4.0-5.6	f/4-f/22	9	0.96-∞
Zuiko ED 90-250mm 1:2.8	f/2.8-f/22	9	2.5-∞
Zuiko ED 150mm 1:2.0	f/2.0-f/22	9	1.4-∞
Sigma 150mm 1:2.8 APO Macro EX DG HSM	f/2.8-f/22	9	0.38-∞
Zuiko ED 300mm 1:2.8	f/2.8-f/22	9	2.4-∞

Angle of view (diagonal)	35mm equivalent	Maximum magnification	Filter thread (mm)	Dimensions (diameter x length mm)	Weight (g)
114°–75°	14–28mm	0.11 x	n/a	86.5 x 119	780
180°	16mm	0.22 x	n/a	79 x 77	485
100°–62°	18–36mm	0.12 x	72	79.5 x 73	275
89–53°	22–44mm	0.13 x	72	75 x 92.5	485
84–20°	24–120mm	0.28 x	72	79.5 x 98.5	575
75–34°	28–70mm	0.12 x	77	86 x 123	900
75–29°	28–84mm	0.19 x	58	65.5 x 61	190
75–24°	28–100mm	0.42 x	67	74 x 93	434
75–24°	28–100mm	0.32 x	72	78.1 x 97.4	490
75–23°	28–108mm	0.26 x	67	74.5 x 88.5	440
75–8.2°	28–300mm	0.36 x	72	78.5 x 90.4	535
62–6.9°	36–360mm	0.23 x	62	78 x 84.5	435
47°	50mm	0.19 x	43	64 x 23.5	95
47°	50mm	0.17 x	62	77.7 x 75	510
39°	60mm	0.1 x	62	76.6 x 64.1	410
34°	70mm	1.0 x	52	71 x 53	165
34–12°	70–200mm	0.09 x	77	96.5 x 213.5	1,650
30–8.2°	80–300mm	0.14 x	58	65.5 x 72	220
24–6.2°	100–400mm	0.21 x	67	86.5 x 157	995
24°	100mm	0.52 x	52	71 x 61.5	300
24°	100mm	0.14 x	77	84.5 x 68.2	505
18–4.1°	140–600mm	0.5 x	58	80 x 127.5	615
14–5°	180–500mm	0.08 x	105	124 x 276	3,270
8.2°	300mm	0.13 x	82	100 x 150	1,465
8.2°	300mm	1.0 x	72	79.6 x 142	920
4.1°	600mm	0.15 x	n/a	127 x 285	3,290

1 » MICRO FOUR THIRDS LENS CHART

Lens Name	Aperture range	Number of aperture blades	Focus range (meters)
Lumix G Vario 7-14mm 1:4.0 ASPH	f/4-f/22	7	0.25-∞
Lumix G Fisheye 8mm 1:3.5	f/3.5-f/22	7	0.1-∞
Zuiko 9-18mm 1:4.0-5.6	f/4-f/22	7	0.25-∞
Zuiko 12mm ED 1:2.0	f/2-f/22	7	0.2-∞
Lumix G 12.5mm 1:12 3D	f/12	-	0.6-∞
Lumix G 14mm 1:2.5 ASPH	f/2.5-f/22	7	0.18-∞
Zuiko ED 14-42mm 1:3.5-5.6	f/3.5-f/22	7	0.25-∞
Zuiko ED 14-42mm 1:3.5-5.6 II	f/3.5-f/22	7	0.25-∞
Lumix G Vario 14-42mm 1:3.5-5.6 ASPH Mega O.I.S.	f/3.5-f/22	7	0.3-∞
Lumix G Vario 14-45mm 1:3.5-5.6 ASPH Mega O.I.S.	f/3.5-f/22	7	0.3-∞
Lumix G Vario HD 14-140mm 1:4-5.8 ASPH Mega O.I.S.	f/4-f/22	7	0.5-∞
Zuiko ED 14-150 1:4.0-5.6	f/4-f/22	7	0.5-∞
Zuiko 17mm 1:2.8	f/2.8-f/22	5	0.2-∞
Lumix G 20mm 1:1.7 ASPH	f/1.7-f/16	7	0.2-∞
Leica DG Summilux 25mm 1:1.4 ASPH	f/1.4-f/16	7	0.3-∞
Voigtländer (Cosina) Nokton 25mm 1:0.95	f/0.95-f/22	10	0.17-∞
Zuiko ED 40-150 1:4.0-5.6	f/4.0-f/22	7	0.9-∞
Leica DG Macro-Elmarit 45mm 1:2.8 ASPH Mega O.I.S.	f/2.8-f/22	7	0.15-∞
Zuiko Digital 45mm 1:1.8	f/1.8-f/22	7	0.5-∞
Lumix G Vario 45-200mm 1:4.0-5.6 Mega O.I.S.	f/4-f/22	7	1-∞
Zuiko ED 75-300mm 1:4.8-6.7	f/4.8-f/22	7	0.9-∞
Lumix G Vario 100-300mm 1:4.0-5.6 Mega O.I.S.	f/4.0-f/22	7	1.5-∞

* When the compatible DMC-GH2 is set to an aspect ratio of 16:9

Angle of view (diagonal)	35mm equivalent	Maximum magnification	Filter thread (mm)	Dimensions (diameter x length mm)	Weight (g)
114–75°	14–28mm	0.08 x	n/a	70 x 83.1	300
180°	16mm	0.20 x	n/a	60.7 x 51.7	165
100–62°	18–36mm	0.1 x	52	56.5 x 49.5	155
84°	24mm	0.08x	46	56 x 43	130
37°*	65mm*	0.02 x	–	57 x 20.5	45
75°	28mm	0.10 x	46	55.5 x 20.5	55
75–29°	28–84mm	0.24 x	40.5	62 x 43.5	150
75–29°	28–84mm	0.19 x	37	56.5 x 50	112
75–29°	28–84mm	0.16 x	52	60.6 x 63.6	165
75–27°	28–90mm	0.17 x	52	60 x 60	195
75–8.8°	28–280mm	0.2 x	62	70 x 84	460
75–8.2°	28–300mm	0.24 x	58	63.5 x 83	260
65°	34mm	0.11 x	37	57 x 22	71
57°	40mm	0.13 x	46	63 x 25.5	100
47°	50mm	0.11 x	46	63 x 55	200
47.3°	50mm	0.26 x	52	58.4 x 70	410
30–8.2°	80–300mm	0.16 x	58	63.5 x 83	190
27°	90mm	1.0 x	46	63 x 62.5	225
27°	90mm	0.11x	37	56 x 46	116
27–6.2°	90–400mm	0.19 x	52	70 x 100	380
16–4.1°	150–600mm	0.18 x	58	70 x 116	430
12–4.1°	200–600mm	0.21 x	67	73.6 x 126	520

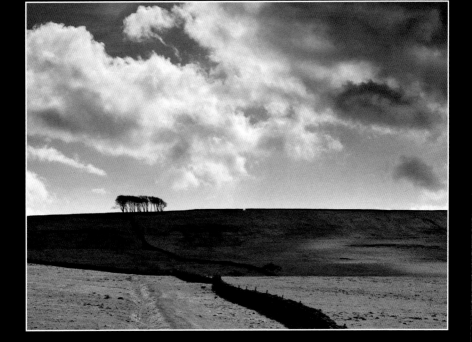

Settings
> *Focal length: 60mm*
> *Aperture: f/8*
> *Shutter speed: 1/160 sec.*
> *ISO 100*

A MOMENT IN TIME ⌄

Thanks to the relative cheapness of high-capacity memory cards, it is tempting to fire away and create multiple versions of essentially the same photograph. However, a more considered approach would save you trawling through hundreds or thousands of photos at the editing stage. The trick is to watch and anticipate the perfect conditions required for a successful photograph. This shot was created after time had been spent watching how the shadows of the clouds drifted across the landscape. The shutter was only fired when I felt that the right balance of light and shade had been achieved.

FOUR THIRDS & MICRO FOUR THIRDS

Settings
> Focal length: 70mm
> Aperture: f/4
> Shutter speed: 1/200 sec.
> ISO 100

FOCUS POINT ⌃

Because of the crop factor, a Four Thirds lens will have a shorter focal length than a lens delivering a similar angle of view on a full-frame camera. This means you will have a greater depth of field than with the equivalent full-frame lens, but this does not mean that you can be sloppy with your focusing: it still pays to focus precisely on the subject of your picture. In this image, the point of focus was the face and, in particular, the eyes of the statue in the foreground. The photograph would not have worked so well if they had been out of focus.

Chapter 2
PANASONIC JOINS IN

2 PANASONIC JOINS IN

In 2006, the promise of Four Thirds as an "open" camera system, with camera models produced by several manufacturers, finally came good: on the first day of the annual Photo Marketing Association (PMA) Show in Florida, Panasonic announced the Panasonic DMC-L1 to the world's press.

» PANASONIC LUMIX DMC-L1 February 2006

PANASONIC LUMIX DMC-L1 ⌃
With Leica D Vario-Elmarit 14–50mm f/2.8–3.5 ASPH lens.

Sensor

Panasonic's L1 was not an entirely fresh design, and its resemblance to the Olympus E-330 was both external and internal. Many of the components from the E-330's optical assembly were borrowed for Panasonic's camera, and the L1 also used the same 7.5 megapixel Live MOS sensor.

However, while this may sound as if Olympus did all of the work, the opposite

was in fact true: the technology was originally developed by Panasonic, but used first by Olympus in the E-330.

Assisting the sensor was Panasonic's proprietary Venus Engine III image processor, which helped to eke as much detail and color out of the sensor as possible, while keeping noise to a minimum. Other tasks performed by the image processor included improving the camera's responsiveness, to minimize shutter lag and boost the burst rate.

Live View

As had already been seen with the E-330, the Live MOS sensor allowed the L1 to benefit from full-time Live View, although unlike the system used by Olympus, the L1's Live View had to be interrupted during AF operations.

Flash

One of the benefits of using an external flash is the ability to angle the head to "bounce" the flash, but this is not possible with most built-in flashes—the flash points

in a fixed direction and that's that. The built-in flash in the L1 was unique in that it could be fired from two different angles: one push opened the flash, pointing it upward, while a second push extended the flash out further and pointed it forward.

Body and lens

Even though the L1 didn't look like a conventional digital SLR, there were two features that pleased experienced photographers. The first of these was a very traditional shutter speed dial on the camera's top plate, which allowed the photographer to change settings accurately without relying on button presses or looking at an LCD.

The second feature was on the lens: turning an aperture ring changed the aperture. Although this fact could be confirmed by looking at the LCD there was something reassuring about clicking a ring into place to make a change to the exposure settings.

JARGON BUSTING: BOUNCE FLASH

This is the technique of reflecting the light from a flash off a surface—often a ceiling or wall—before it reaches the subject. This helps to spread the light, softening it and producing a less harsh result than direct flash.

LEICA DIGILUX 3

Leica is a name that is synonymous with quality and long-established photographic values, and is the company that designed the kit lens supplied with the L1. It was no surprise then, that the lens exuded quality and featured something as traditional as an aperture ring.

What may have surprised some people, though, was the release of the Leica Digilux 3 camera in September 2006. This was essentially a repackaged L1 and, although the basic design didn't alter greatly, the camera looked much more like a Leica product, with a distinctive metal top plate and black body. The camera marked a departure for Leica as it was the company's first interchangeable lens digital camera. It also remains the company's only camera-based foray into the world of Four Thirds.

LEICA DIGILUX 3 ⌃

Sensor

Resolution 7.5 megapixels (effective)
Type 4:3 aspect ratio Live MOS sensor

Image processor

Venus Engine III LSI

Body

Construction Materials Plastic
Lens Mount Four Thirds

Image sizes

Maximum 3136 x 2352 pixels
Minimum 1920 x 1080 pixels

Storage media

SD memory card (compatible with SDHC)

File formats

JPEG (L; M; S); TIFF; Raw (12-bit)

Focus

Type TTL Phase Difference Detection
Modes Single AF; Continuous AF; Manual
Focus Areas 3 points
Focus Selection Automatic; Manual
Detection Range EV0–19 (at ISO 100)
Depth of Field Preview No

Exposure

Metering Type 49-zone multipattern system (optical view finder); 256-zone multipattern system (Live View)
Metering Modes Intelligent Multiple; Center-weighted; Spot (Approx. 2%)
Exposure Modes Programmed AE (**P**); Aperture Priority (**A**); Shutter Priority (**S**); Manual (**M**)
ISO Modes Auto/Manual
ISO Range 100–1600
Exposure Compensation ±2EV in ⅓, ⅔, or 1EV steps
Exposure Bracketing 3 or 5 frames; ±2EV in ⅓EV steps

Shutter

Type Electronically-controlled focal-plane
Shutter Speed 60 seconds–1/4000 sec.; Up to 8 minutes (Bulb)

Viewfinder

Type Eye-level TTL Optical Porro mirror
Coverage Approx. 95%
Magnification Approx. x0.93 (with 50mm lens set to infinity attached)
Eyepoint Approx. 18mm at -1 diopters
Diopter Adjustment -3.0 to +1

Drive system

Modes Single; Sequential Shooting
Max. Frame Rate 3 fps
Max. Frame Burst 6 frames (Raw/TIFF);
Resolution and compression ratio
dependent (JPEG HQ/SQ)
Self Timer 2 seconds; 10 seconds

Flash

Built-in Flash Yes
Guide Number 33ft/10m @ ISO 100
(Leica Digilux 3 42ft/13m @ ISO 100)
Modes Auto; Red-eye Reduction; Slow
Sync with Red-eye Reduction; 2nd Curtain
Slow Sync; Fill-in
Sync Speed 1/160 sec.
Flash Exposure Compensation ±2EV in
⅓EV steps
Other Information Flash can be tilted for
bounce flash

Playback monitor

Type HyperCrystal LCD (Colour TFT)
Dimensions 2.5in (6.35cm)
Resolution 207,000 pixels
Coverage 100%
Languages English; German; French;
Italian; Spanish; Polish; Czech; Hungarian;
Chinese (Traditional); Chinese
(Simplified); Russian; Japanese
Live View Digital Zoom 2x or 4x

Connections

External Interfaces USB 2.0
Video Out Jack Yes (NTSC or PAL)
Other Flash hotshoe; Optional remote
control

Dimensions

Size 5.7 x 3.4 x 3in (146 x 87 x 77mm)
Weight 1.2lb (530g)

Included software

Lumix Simple Viewer; PHOTOfunSTUDIO;
SILKYPIX Developer Studio 2.0 SE

Power

Rechargeable 1500 mAh Li-ion battery
pack; Dummy battery for AC power input

2 ›› EXPOSURE

The word exposure has two related meanings in photography. The first—"to make an exposure"—is the act of letting light fall on a digital sensor (or piece of film) to produce an image. The second meaning, and the one discussed below, is a measurement of how much light is needed to create the desired image.

Shutter speed

There are two controls on a camera that control the amount of light that creates an image, and the first of these is the shutter speed. This is the length of time that the shutter inside the camera is open, exposing the sensor to light. This can be as fleeting as 1/8000 sec., to whole seconds, minutes, or, in some instances, hours if the camera is set to Bulb and the shutter is locked open.

The traditional range of shutter speeds on a camera follows the sequence 1/60 sec., 1/125 sec., 1/250 sec., 1/500 sec., and so on. Reading this sequence from left to right, the amount of light let through to the sensor is halved at each step (or, if reading from right to left, the amount of light is doubled). This difference is known as a "stop," so, for example, there is a one stop difference between 1/60 sec. and 1/125 sec., and two stops between 1/60 sec. and 1/250 sec.

Aperture

The second method of controlling light is to adjust the size of the aperture in the lens. The aperture is a hole that is made up of blades that can be opened and closed to increase or decrease its size, and therefore regulate the amount of light passing through it. When the aperture of a lens is at its widest it is said to be at "maximum aperture," and when closed down to its smallest, it is at "minimum aperture."

Note:
Most cameras allow shutter speed and aperture adjustments to be made in ½- or even ⅓-stop increments. This provides an increased number of settings, but does not affect the basic principle of how they work.

TUNISIAN CAT ››
Fast shutter speeds are ideal when your subject is liable to run off at a moment's notice, even if that means increasing the ISO setting.

The size of the aperture is measured in units known as "f-stops," and the smaller the number, the wider the aperture (bigger the hole). Conversely, the higher the number, the smaller the aperture.

A typical f-stop range on a camera lens might be: f/4, f/5.6, f/8, f/11, f/16, f/22 and, reading this sequence from left to right, the amount of light let through to the sensor is halved at each step (or doubled if reading from right to left). This difference is also known as a stop (as with the shutter speed), so there is a one stop difference between f/4 and f/5.6, for example, and two stops between f/5.6 and f/11.

JARGON BUSTING: EXPOSURE COMPENSATION

You do not need to use the exposure recommended by the camera and you may choose to over- or underexpose your images intentionally, making them lighter or darker respectively. You do this by applying exposure compensation, which is achieved either by using a dedicated button on the camera, or via a menu setting. A positive (+) value will increase the exposure (overexpose), while a negative (-) value will decrease the exposure (underexpose). The greater the compensation amount applied, the greater the difference in the exposure.

RELATIONSHIP

If you change either the shutter speed or aperture by one stop, then the other may also be altered by one stop (in the opposite direction) to maintain the same exposure. For example, the photograph shown here was shot using an aperture setting of f/11 and a shutter speed of 1/250 sec. From the following grid, you can see that a number of other combinations of aperture and shutter speed could have been used to achieve the exact same exposure.

Shutter Speed:	1/60	1/125	1/250	1/500	1/1000
Aperture:	f/22	f/16	f/11	f/8	f/5.6

Motion

Unlike video, a still image can only ever *imply* that a subject was moving during the exposure. This is achieved by carefully choosing a shutter speed that helps to convey a sense of motion.

A fast shutter speed can be used to "freeze" movement, and the faster your subject is moving, the faster the shutter speed will need to be to freeze the movement. For example, if you wanted a sharp image of a racing car you might need to use a shutter speed as fast as 1/4000 sec., but a person walking may only require a shutter speed of 1/125 sec. to freeze them in mid-stride.

However, freezing action does not necessarily help to imply motion: if your subject is sharp, there will not be much difference between a shot of them moving and a photograph in which they are stationary. Rather counter-intuitively, motion is often conveyed more successfully when longer shutter speeds are used. This will soften your subject, as its movement is recorded as a blur, but this helps to imply a sense of motion. The longer the shutter speed, the greater the effect, but too long a shutter speed and your subject may disappear from the picture entirely, leaving

JARGON BUSTING: PANNING

Panning is the technique of moving your camera to follow the motion of your subject, keeping the subject in the same position within the viewfinder as you do so. The shot is taken halfway through the panning movement. This will allow you to "freeze" your subject with a much slower shutter speed than would otherwise be required, with a sense of movement coming from the resulting blurred background.

WATER ⌄

A shutter speed of 6 seconds has reduced the water in this stream to a milky blur. This has helped to define the shape of the main rock in the foreground.

only a ghostly trace across the image. If your subject is moving across the image frame, panning is an effective technique.

If your camera has a Bulb mode this will allow you to lock the shutter open, and manually close it after an exposure of several seconds, or even minutes. This is particularly effective on clear, starry nights, or when photographing moving water.

Depth of field

When you focus your camera, the actual focus point is a very thin plane that is parallel to the camera. Sharpness, both in front of, and behind this point, is achieved by altering the aperture of the lens. As the lens aperture is made smaller, the zone of sharpness increases and this effect is known as "depth of field." How far the depth of field extends is dependent on several factors: the lens aperture, the focal length of the lens, and the camera-to-subject distance, but it always extends further behind the point of focus than in front of it.

A shorter focal length lens has a greater depth of field than a longer lens at the same aperture: using a lens with a focal length of 14mm to photograph a landscape can achieve front-to-back sharpness with even a moderately small aperture, such as f/5.6, for example.

As you focus more closely on your subject, the depth of field diminishes. Macro photography, with its very small camera-to-subject distances, often means dealing with a very shallow depth of field, requiring accurate focusing on the subject.

Using depth of field creatively is a key skill. Although it is tempting to use the smallest aperture setting to maximize the sharpness in your photographs, selective focus can be just as exciting, visually.

FRONT-TO-BACK SHARPNESS ≫
To make sure that the blades of grass in the foreground were sharp, as well as the building behind, I used an aperture of f/16 here.

2 » OLYMPUS E-400 September 2006

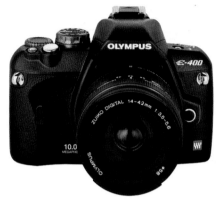

OLYMPUS E-400 ⌄
With Zuiko ED 14–42mm f/3.5–5.6 lens.

The E-400 represents a moment when certain aspects of the Four Thirds project came to an end. The sensor—a 10-megapixel CCD device—was the last developed by Kodak to be used in a Four Thirds body, for example, and the E-400 was also the last Four Thirds camera that did not feature Live View.

To the puzzlement of most people (at the time), Olympus did not release the E-400 in North America, which is why it does not appear as an "Evolt" model.

Small packages
While the E-400 contained a few "end of season" features that made it appear slightly dated compared to its peers, it should still be remembered for what it achieved. At the time of release it was the smallest and lightest digital SLR available and, for that reason, a few critics hailed it as a worthy successor to Olympus's revered OM-10 35mm SLR.

Despite its size, it was still a feature-packed camera, containing more than 30 scene modes for creative shooting, which included such esoteric options as high- and low-key, and an underwater mode. Of course the camera itself wasn't waterproof, but a keen diver could use the optional PT-E03 waterproof case, which was suitable for depths of up to 130ft/40m.

Lenses
To coincide with the launch of the E-400, Olympus also released two new lenses—the Zuiko 14–42mm f/3.5–5.6 and the Zuiko 40–150mm f/4.0–5.6. Both were available as a kit lens with the E-400 and introduced a stylish blue ring around the lens barrel. This was a new look for the Olympus E-system lens range, although it was a purely esthetic touch.

› Olympus E-400 Specifications

Sensor
Resolution 10 megapixels (effective)
Type 4:3 aspect ratio CCD sensor

Image processor
TruePic Turbo

Body
Construction Materials Glass-fiber reinforced plastics
Lens Mount Four Thirds

Image sizes
Maximum 3648 x 2736 pixels
Minimum 640 x 480 pixels

Storage media
CompactFlash (Types I & II); Micro Drive; xD Picture Card (Dual Slot)

File formats
JPEG (SHQ/HQ/SQ); Raw (12-bit)

Focus
Type TTL Phase Difference Detection
Modes Single AF; Continuous AF; Manual Focus; Single AF + MF; Continuous AF + MF; Focus Tracking (in Continuous AF)
Focus Areas 3 points
Focus Selection Automatic; Manual
Detection Range EV0–19 (at ISO 100)
Depth of Field Preview Yes

Exposure
Metering Type TTL with 49-zone multi-pattern system
Metering Modes Digital ESP; Center-weighted; Spot (Approx. 2%; Highlight Spot; Shadow Spot
Exposure Modes Auto; Program AE (**P**); Aperture Priority (**A**); Shutter Priority (**S**); Manual (**M**)
Scene Modes Portrait; Landscape; Landscape with Portrait; Night Scene; Night Scene with portrait; Children; Sports; High key; Low key; Image Stabilization Mode; Macro; Nature Macro; Candle; Sunset; Fireworks; Documents; Beach and Snow; Underwater Wide; Underwater Macro
ISO Modes Auto/Manual
ISO Range 100–400 (Auto); 100–1600 ISO in 1/3EV steps (Manual)
Exposure Compensation ±5EV in ⅓EV steps
Exposure Bracketing 3 frames in ⅓, ½, or 1EV steps

Shutter
Type Electronically-controlled focal-plane
Shutter Speed 60 seconds–1/4000 sec. (**P**, **S**, and **M**); 2 seconds–1/4000 sec. (**A**); 4 seconds–1/4000 sec. (Scene Mode; mode dependent); Up to 8 minutes (Bulb)

Viewfinder

Type Eye-level TTL optical single lens
Coverage Approx. 95%
Magnification Approx. x0.92 (with 50mm lens set to infinity attached)
Eyepoint Approx. 14mm
Diopter Adjustment -3.0 to +1

Drive system

Modes Single; Sequential Shooting
Max. Frame Rate 3 fps
Max. Frame Burst 5 frames (Raw); 10 frames (JPEG HQ)
Self Timer 2 seconds; 12 seconds

Flash

Built-in Flash Yes
Guide Number 33ft/10m @ ISO 100
Modes Auto; Red-eye Reduction; Slow Sync; Slow Sync with Red-eye Reduction; 2nd Curtain Slow Sync; Fill-in; Manual (external flash only)
Sync Speed 1/180 sec.; 1/4000 sec. Super FP mode
Flash Exposure Compensation ±2EV in ⅓EV steps

Playback monitor

Type HyperCrystal LCD (Colour TFT)
Dimensions 2.5in (6.35cm)
Resolution 215,000 pixels
Coverage 100%

Languages English; German; French; Spanish; Italian; Russian; Czech; Dutch; Danish; Polish (other languages available as Internet downloads)

Connections

External Interfaces USB/Video Multiconnector (NTSC or PAL)
Video Out Jack No
Other Flash hotshoe

Dimensions

Size 5.1 x 3.6 x 2.1in (130 x 91 x 53mm)
Weight 13.2oz (375g)

Included software

Olympus Master

Power

Rechargeable 1150 mAh Li-ion battery pack BLS-1

» OLYMPUS EVOLT E-410 April 2007

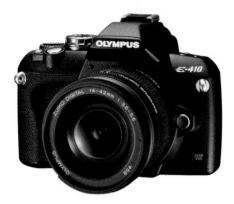

OLYMPUS E-410 ⌃
With Zuiko ED 14–42mm f/3.5–5.6 lens.

Olympus's decision not to release the E-400 in North America was explained just six months later, with the global launch of the E-410. The newcomer was essentially a subtly improved version of the E-400, with *subtle* most definitely being the operative word.

E-410 versus E-400

Although very similar in both form and function, the E-410 did possess a few differences to its immediate predecessor, the E-400, the most notable of which was the inclusion of Live View.

Sensor The E-410 houses a 10-megapixel Matsushita Live MOS with full-time Live View capability.

Image processor Upgraded to TruePic III for improved image noise characteristics and faster operation.

Focus AF in Live View (using the Phase-Detection system requiring interruption of Live View).

Continuous shooting Remains at 3fps second (as the E-400), but has an unlimited burst rate when the camera is shooting JPEG HQ. This decreases to a 7 frame burst when shooting Raw.

Panorama Additional Panorama scene mode (requires Olympus xD Picture Card).

In photography there are two metering methods used to determine the shutter and aperture settings needed for a correct exposure. The first method is to use a handheld meter to measure the amount of light falling onto a scene, which is known as *incident metering*. The second method is to use a meter built into a camera and measure the amount of light that is reflected from the scene. This is known, unsurprisingly, as *reflective metering*.

Using the camera meter

The problem with reflective metering is that the camera's lightmeter can be fooled if the scene it is aimed at has a lot of extremely bright or extremely dark areas. When it reads a scene, a lightmeter averages out the tones to give a correct exposure for an 18% gray card. If a scene has a lot of light tones—a snowy landscape is a good example—then the meter will tend to underexpose, as it tries to average the scene to a mid-gray ideal. Conversely, if a scene has a lot of dark tones, the opposite is likely to happen, with the camera's meter overexposing for the same reason.

Fortunately, you don't have to rely on a camera's meter for the correct exposure. The greatest control is gained by switching to Manual (**M**) and setting the shutter and aperture values without the camera intervening. Alternatively, when using Program (**P**), Aperture Priority (**A**), or Shutter Priority (**S**), you can use exposure compensation, dialling in one or two stops of positive compensation to keep a snow scene bright, for example.

WINTER ⩔
Because there were a lot of light, reflective tones in this scene, I had to use +1½ stops of exposure compensation to avoid underexposure.

JARGON BUSTING: 18% GRAY CARD

An 18% gray card is so called because it reflects 18% of the light that falls on it. When the gray card is held in the same light as your scene, metering directly from it will give you a guide to the correct exposure. Green grass and stone roughly correspond to the same reflectivity as an 18% gray card and can be used in much the same way.

IN-CAMERA METERING MODES

There are three main types of metering pattern used in Four Thirds cameras, each of which has its advantages and disadvantages.

Digital ESP/Intelligent Multiple 🔲

This metering system is generally the default option on most cameras. It works by dividing the scene into separate areas and measuring the light in each of these independently. The camera then calculates the overall exposure by averaging the measurements taken from each area. On some cameras, the focus point is also taken into consideration, biasing the exposure to that point. This system is generally very accurate, and can cope with a wide range of different lighting conditions.

Center-weighted average 🔲

The light level for the entire scene is measured, but the exposure is biased to the center. This is an older metering system than Digital ESP/Intelligent Multiple, but is still accurate when you understand how it works. Care must be taken when your subject is not central in the frame, but it is very accurate when exposing for centrally placed, backlit subjects.

Spot metering 🔲

This mode takes a reading from a small area at the center of the image, making it a very accurate way of determining the exposure for a specific part of the image. Olympus provides shadow and highlight spot metering on some of its cameras, which applies automatic exposure compensation when metering from dark and light areas of a scene respectively.

Settings
> Focal length: 12mm
> Aperture: f/14
> Shutter speed: 1/15 sec.
> ISO 100

FRAMING ⌃

Part of the art of photography is conveying a sense of
three-dimensional depth in a two-dimensional medium.
One way to achieve this is to imply a sense of scale. In this
photograph, the broken, dry-stone wall in the foreground
frames the tree in the background. Because we know that
trees are generally far larger than walls, we can immediately
see that there must be some distance between the two
elements. If the wall wasn't there and we only had open

BULB ⌃

Before electronics, the shutter on a camera was fired by squeezing a rubber bulb, and the longer you squeezed, the longer the shutter would be held open. Fortunately, we no longer have to use such a crude system, but the concept lives on in the form of Bulb mode. Bulb is most useful when the light levels are low and the required shutter speed needs to be measured in minutes, rather than seconds (or fractions of a second).

For this image, the camera was pointed at a clear night sky and the shutter locked open in Bulb mode using a remote release. As the earth moved during the exposure, the stars left an attractive trail across the sky. This technique is best attempted with a freshly charged battery and warm clothing!

Settings
> Focal length: 12mm
> Aperture: f/11
> Shutter speed: 30 min.
> ISO 100

Chapter 3
THE RANGE EXPANDS

3 THE RANGE EXPANDS

2007 saw the Four Thirds standard expand rapidly, as both of the main players—Olympus and Panasonic—launched further digital SLR camera bodies that boasted ever-more-sophisticated features.

» OLYMPUS EVOLT E-510 June 2007

OLYMPUS EVOLT E-510 ⌃
2007's successor to the popular E-500.

The E-510 was the successor to 2005's E-500 and in two years digital camera technology had moved on considerably. This was reflected in the E-510's expanded feature set, but it was not an entirely new camera—the sensor was essentially the same as that found in the E-400/E-410, and features such as Live View had been tried out already in the earlier E-330.

Body
The design of the E-510 was very traditional, with a notably comfortable grip, and easy to understand mode dial. Although smaller and lighter than many contemporary cameras from other manufacturers, the E-510 was significantly larger than the Olympus E-410. One advantage of this increase in size was that the battery in the E-510 was larger, which meant an approximate 25% increase in battery life over the E-410: sometimes size *is* important.

The layout of the buttons on the rear of the camera was logical and it was easy to get the impression that Olympus listened to photographers when designing the camera. Neat touches included the addition of dedicated white balance, ISO, AF, and metering buttons, as well as a highly customizable Fn (function) button.

Stabilized
One of the headline features of the E-510 was the built-in, sensor-based image stabilization, which used a supersonic wave drive similar to the one employed to prevent dust from settling on the sensor.

› Olympus Evolt E-510 Specifications

Sensor
Resolution 10 megapixels (effective)
Type 4:3 aspect ratio Live MOS sensor

Image processor
TruePic III

Body
Construction Materials Glass reinforced plastics
Lens Mount Four Thirds

Image sizes
Maximum 3648 x 2736 pixels
Minimum 640 x 480 pixels

Storage media
CompactFlash (Types I & II); Micro Drive; xD Picture Card

File formats
JPEG (SHQ/HQ/SQ); Raw (12-bit); Raw+JPEG

Focus
Type TTL Phase Difference Detection
Modes Single AF; Continuous AF; Manual Focus; Single AF + MF; Continuous AF + MF; Focus Tracking (in Continuous AF)
Focus Areas 3 points
Focus Selection Automatic; Manual
Detection Range EV0–19 (at ISO 100)
Depth of Field Preview Yes

Exposure
Metering Type TTL with 49-zone multipattern system
Metering Modes Digital ESP; Center-weighted; Spot (Approx. 2%); Highlight Spot; Shadow Spot
Exposure Modes Auto; Program AE (**P**); Aperture Priority (**A**); Shutter Priority (**S**); Manual (**M**)
Scene Modes Portrait; Landscape; Landscape with Portrait; Night Scene; Night Scene with Portrait; Children; Sports; High Key; Low Key; Image Stabilization Mode; Macro; Nature Macro; Candle; Sunset; Fireworks; Documents; Beach and Snow; Panorama
ISO Modes Auto/Manual
ISO Range 100–400 (Auto); 100–1600 (Manual)
Exposure Compensation ±5EV in ⅓EV steps
Exposure Bracketing 3 frames in ⅓, ½, ⅔, or 1EV steps

Shutter
Type Electronically-controlled focal-plane
Shutter Speed 60 seconds–1/4000 sec. (**P**, **S**, and **M**); 2 seconds–1/4000 sec. (**A**); 4 seconds–1/4000 sec. (Scene Mode; mode dependent); Up to 8 minutes (Bulb)

Image stabilizer
Type Sensor shift
Compensation Range Approx. 4EV steps

Viewfinder

Type Eye-level TTL single lens reflex
Coverage Approx. 95%
Magnification Approx. x0.92 (with 50mm lens set to infinity)
Eyepoint Approx. 14mm
Diopter Adjustment -3.0 to +1

Drive system

Modes Single; Sequential Shooting
Max. Frame Rate 3fps
Max. Frame Burst 8 frames (Raw); Up to card capacity (JPEG HQ)
Self Timer 2 seconds; 12 seconds

Flash

Built-in Flash Yes
Guide Number 40ft/12m @ ISO 100
Modes Auto; Red-eye Reduction; Slow Sync; Slow Sync with Red-eye Reduction; 2nd Curtain Slow Sync; Fill-in; Manual (external flash only)
Sync Speed 1/180 sec.; 1/4000 sec. Super FP mode
Flash Exposure Compensation ±2EV in ½EV steps

Playback monitor

Type HyperCrystal LCD (Color TFT)
Dimensions 2.5in (6.35cm)
Resolution 230,000 pixels
Coverage 100%
Languages English; German; French; Spanish; Italian; Russian; Czech; Dutch; Danish; Polish (other languages available as Internet downloads)
Live View 100% field of view; Exposure adjustment preview; White balance adjustment preview; Optional gridline overlay; 7x and 10x magnification; MF/S-AF frame display; AF point display; shooting information; Histogram; IS activating mode

Connections

External Interfaces USB 2.0
Video Out Jack Yes (NTSC or PAL selectable)
Other Flash hotshoe; Optional IR remote control

Dimensions

Size 5.4 x 3.6 x 2.7in (136 x 92 x 68mm)
Weight 16.2oz (460g)

Included software

Olympus Master 2.0

Power

Rechargeable 1500 mAh Li-ion battery pack BLM-1

» OLYMPUS EVOLT E-520 June 2008

OLYMPUS EVOLT E-520 «
With Zuiko ED 14–42mm f/3.5–5.6 lens.

Launched just 12 months after the E-510, the E-520 shared the same basic design and sensor as its predecessor, but the newcomer incorporated a number of upgrades and improvements:

Drive mode Continuous shooting speed increased from 3fps to 3.5fps.

Flash Wireless flash control enabled, with the ability to control up to three groups.

LCD Screen size increased from 2.5 inches to 2.7 inches.

Autofocus Contrast detection and face detection autofocus with compatible lenses in Live View mode.

Image stabilization Improvements made to allow for panning, while maintaining stabilization in the opposing axis.

Exposure Shadow Adjustment Technology improves the dynamic range by identifying shadow areas and adjusting the exposure.

3 » WHITE BALANCE

Pure, neutral white light is surprisingly rare in nature and from artificial sources—most light has some color tint to it. Unless the color is particularly strong, our eyes are remarkably good at correcting for this, so it often comes as a surprise when a photographic image has a strong color cast that we did not perceive at the time. This variation in the color of light is due to its color temperature, which is measured in degrees Kelvin (K).

The term "white balance" is derived from the act of electronically adjusting an image so that any color tint is removed and anything white appears neutral. For example, if the light has a cool blue tint, the camera's white balance will add orange-red to compensate and produce a neutral result. Similarly, blue will be used to compensate for a warm tint.

Most Four Thirds cameras feature an automatic white balance option, as well as preset white balance settings to deal with specific lighting conditions. More sophisticated still is the option to set a custom Kelvin value to finely adjust the white balance.

The white balance can also be used creatively to change the tone of an image, perhaps by using color to help express emotion in an image. Blue, for example, is perceived as conveying negative emotions, so "cooling" an image has a different emotional effect to "warming" it.

CHANGING THE WHITE BALANCE »

The photograph to the right was captured with the white balance set to 5500K—the setting for "daylight." The images opposite show the effect of using a different white balance for the same shot.

3,000K

4,000K

5,000K

6,000K

7,000K

8,000K

9,000K

10,000K

WHITE BALANCE PRESETS

The most commonly seen white balance presets on digital cameras are for specific lighting conditions:

Preset	Use
AUTO	The camera will automatically attempt to detect and correct any color tint.
Overcast conditions ☁	Use outside when the sky is cloudy, to avoid images appearing "cool."
Daylight ☀	The color temperature of daylight at midday.
Fluorescent ▤	Warmer than daylight, fluorescent lighting often has a slight green tint.
Incandescent 🔆	Incandescent—or tungsten—lighting is used in household domestic light bulbs and is very "warm," requiring a lot of blue correction.
Flash WB⚡	Flash is very close in color temperature to daylight and the white balance presets are often interchangeable.
Shade ⌂	The ambient light in open shade is often very cool (blue), as it is being lit primarily by the blue sky above. This white balance preset warms up the image considerably.
Custom ⌷	Allows you to create an accurate white balance setting for a very specific lighting setup.

COLOR TEMPERATURE »

The diagram on the page opposite shows the approximate color temperature of light in a variety of conditions. In order for a white subject to be neutral, the opposite color must be added, so the camera would need to add blue to counter the warm orange/red bias of incandescent lighting, for example.

10000K	Blue sky
9000K	
8000K	Shade
7000K	
6000K	Overcast conditions
5500K	Flash
5500K	Daylight
5000K	
4000K	Fluorescent
3000K	Incandescent
2000K	
1000K	Candlelight

» PANASONIC LUMIX DMC-L10 October 2007

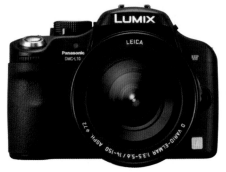

PANASONIC LUMIX DMC-L10 «
With a wide-ranging Leica D Vario-Elmar
14–150mm f/3.8–5.6 zoom lens.

The Panasonic DMC-L10 was a far more conventional-looking digital SLR than its predecessor, the L1, and was obviously intended to show established camera manufacturers such as Canon and Nikon that Panasonic was serious about making inroads into the digital camera market.

Sensor

The L10 used a Live MOS sensor, necessary for Live View, with Panasonic claiming that the sensor delivered superior image quality due to improvements in light reception at the photodiode level.

Supporting the sensor was the Venus Engine III image processor, derived from the unit in the L1. One of the main functions of the processor was to suppress image noise, which the Venus Engine III achieved by first distinguishing between chromatic and luminance noise. It then suppressed the more noticeable (and less attractive) chromatic noise, while the luminance noise (which resembles film grain), was targeted less aggressively.

JARGON BUSTING: PHOTODIODE

A photodiode converts photons of light into an electrical signal. A digital sensor is covered in an array of photodiodes, each of which forms the basis for a pixel in a digital image.

Live View

Although the L1 featured Live View, Panasonic arguably got it right with the L10, as the camera's contrast-detection AF system meant that, for the first time, Live View could remain active during focusing. However, this facility required a lens designed for this purpose, which in the case of the L10's kit lens was the Leica D Vario-Elmar 14–50mm f/3.8–5.6.

The L10 was also the first digital SLR to feature face detection, with the ability to recognize up to 15 faces at any one time. The ability to zoom into a Live View image to check focus was equally revolutionary, particularly as the viewfinder was small.

It was not just focusing that revealed a difference between the viewfinder and Live View. Using the viewfinder, exposure was determined using a through-the-lens 49-zone multipattern meter, but when the camera was switched to Live View, the imaging sensor itself metered the scene, determining the optimum exposure by measuring 256 separate zones.

Rear LCD screen

Using a camera can be frustrating when it is low to the ground: it becomes difficult, or perhaps impossible, to see through the viewfinder, while the rear LCD screen can also be at an awkward angle.

The L10, however, incorporated an articulated LCD screen that could be rotated through 270°, instantly proving how useful Live View could be for photographers looking to exploit less conventional, and more creative shooting positions.

PANASONIC LUMIX DMC-L10　　**»**
With a Leica D Vario-Elmar 14–50mm f/3.8–5.6 "kit" lens.

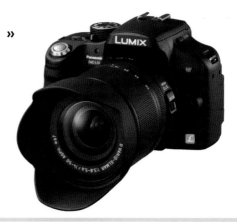

› Panasonic Lumix DMC-L10 Specifications

Sensor

Resolution 10.1 megapixels (effective)
Type 4:3 aspect ratio CCD sensor;
17.3mm x 13.0mm effective area

Image processor

Venus Engine III

Body

Construction Materials Metal chassis,
plastic outer shell
Lens Mount Four Thirds

Image sizes

Maximum 3648 x 2736 pixels
Minimum 1920 x 1080 pixels

Storage media

SD memory card (compatible with SDHC)

File formats

JPEG (Fine/Standard); Raw (12-bit)

Focus

Type TTL Phase Difference Detection;
Contrast AF (Live View mode)
Modes Single AF; Continuous AF;
Manual Focus
Focus Areas TTL Phase Difference
Detection 3 points; Contrast AF 9 points
Focus Selection Automatic; Manual
Detection Range TTL Phase Difference
Detection EV0–19 (at ISO 100); Contrast
AF EV0–20
Depth of Field Preview No

Exposure

Metering Type TTL: 49-zone multipattern
system; Live View mode: 256 zone
multipattern
Metering Modes Intelligent Multiple;
Center-weighted; Spot
Exposure Modes Programmed AE (**P**);
Aperture Priority (**A**); Shutter Priority (**S**);
Manual (**M**)
Scene Modes Portrait; Scenery; Macro;
Sports; Night Portrait
ISO Modes Auto/Manual; Intelligent ISO
(Live View mode only)
ISO Range 100–1600
Exposure Compensation ±2EV in ⅓EV steps
Exposure Bracketing 3 frames, ±2 stops, in
⅓–2EV steps

Shutter

Type Focal-plane shutter
Shutter Speed 60 seconds–1/4000 sec.;
Up to 8 minutes (Bulb)

Viewfinder

Type Eye-level TTL Optical Penta Mirror
Coverage Approx. 95%
Magnification Approx. x0.92 (with 50mm
lens set to infinity)
Eyepoint Approx. 14mm at -1 diopters
Diopter Adjustment -3.0 to +1

Drive system

Modes Single; Sequential Shooting
Max. Frame Rate 3fps

Max. Frame Burst 3 frames (Raw/TIFF);
Up to card capacity (JPEG; resolution
and compression dependent)
Self Timer 2 seconds; 10 seconds;
10 seconds (3 images)

Flash
Built-in Flash Yes
Guide Number 36ft/11m @ ISO 100
Modes Auto; Auto Red-eye Reduction;
Forced On; Red-eye Reduction; Slow
Sync; Slow Sync Red-eye Reduction;
Sync Speed 1/160 sec.
Flash Exposure Compensation ±2EV in
⅓EV steps
Other Information 1st and 2nd curtain
sync selectable

Playback monitor
Type Low-temperature Polycrystalline
TFT LCD
Dimensions 2.5in (6.35cm)
Resolution 207,000 pixels
Coverage 100%
Languages English; German; French;
Italian; Spanish; Polish; Czech; Hungarian;
Russian; Chinese (Traditional); Chinese
(Simplified); Dutch; Thai; Korean; Turkish;
Portuguese; Arabic; Persian; Japanese
Live View 2x and 4x magnification; Extra
Optical Zoom

Connections
External Interfaces USB 2.0
Video Out Jack Yes (NTSC or PAL)
Other Flash hotshoe; Optional wired
remote control DMW-RSL1

Dimensions
Size 5.29 x 3.74 x 3in (134.5 x 95.5 x 77mm)
Weight 1.05lb (480g)

Included software
PHOTOfunSTUDIO; SILKYPIX Developer
Studio 2.1 SE; Lumix Simple Viewer

Power
Rechargeable 1320mAH Li-ion battery;
Dummy battery for connection to AC
mains adapter

Settings
> Focal length: 24mm
> Aperture: f/16
> Shutter speed: 1/2 sec.
> ISO 100

Settings
> Focal length: 40mm
> Aperture: f/13
> Shutter speed: 1/40 sec.
> ISO 100

DAYTIME ⌃

The light at midday is much "cooler" than it is at dusk and dawn, particularly in the summer months, away from the equator. Contrast can also be a problem at this time of day, but with a little imagination it is still possible to make pictures that are esthetically successful.

3 » OLYMPUS E-3 November 2007

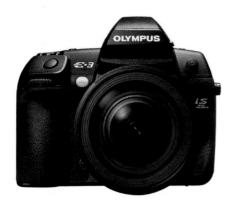

OLYMPUS E-3 ⌃

To many observers, the four-year gap between the E-1 and its successor, the E-3, suggested that Olympus had forsaken the professional photographers that it had originally set out to impress. Therefore, the E-3 needed to be very good if it was to gain favor with the professional market.

Following on from the E-1, the E-3 was designed for a tough life, and it was bigger and bulkier than any other camera in the Olympus line-up at the time. The E-3 was also manufactured using a new casting technique that increased the strength of its magnesium alloy chassis, and the various buttons and dials were sealed with rubber gaskets to reduce the chance of water or dust making its way inside the camera body. Even the shutter mechanism was improved and rated for 150,000 cycles—more than enough for several years of heavy professional use.

Autofocus

As robust as the camera's build was, it was the E-3's autofocus system that Olympus saw as its headline feature. Touted as the "world's fastest" (at the time), the twin cross-type 11-point AF sensor was equally effective on both the horizontal and vertical axes, and the AF target points could be used individually or collectively to predict movement and maintain focus.

To complement the new AF system, Olympus released the first of its SWD lenses: the ED 12–60mm f2.8–4.0 SWD, ED 50–200mm f2.8–3.5 SWD, and the ED 14–35mm f2.0 SWD. The combination of the new AF system and SWD lenses promised a doubling of focusing speed over existing Olympus lenses, and certainly sounded as if it would meet the demands of the professional user.

Live View

The LCD on the E-3 was a 2.5-inch, 230,000 pixel unit, which was smaller in comparison to the camera's main competitors. The saving grace was the fact that the screen was articulated, making Live View a pleasure to use, particularly when the E-3 was low to the ground or above head height.

A Live View system requires the use of a Live MOS sensor, and the sensor used by the E-3 carried a 10.1 megapixel resolution. This was a comparatively low resolution compared to those used by Olympus's rivals, but in a number of respects this was a good thing: too high a resolution can result in a camera that exceeds the capabilities of all but the very best lenses, and struggles with noise at high ISO settings. By sticking to 10.1 megapixels, Olympus was able to deliver a sensor that coped admirably with most people's needs.

Stability

The SWD motor technology was not only used in Olympus's new lenses—inside the E-3, the motors were also employed to provide in-camera image stabilization claimed to deliver 5 stops of compensation. The advantage with this system is that every Four Thirds lens can benefit from it, including wide-angle lenses, which are rarely available with image stabilization.

ARTICULATED SCREEN »
The E-3's rear LCD screen was articulated, making it perfectly suited to high-angle and low-angle shooting. The camera is shown here with the optional HLD-4 power grip.

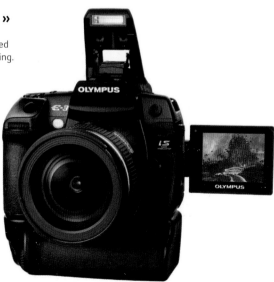

Sensor

Resolution 10.1 megapixels (effective)
Type 4:3 aspect ratio High Speed Live
MOS sensor

Image processor

TruePic III

Body

Construction Materials Magnesium alloy
Lens Mount Four Thirds

Image sizes

Maximum 3648 x 2736 pixels
Minimum 640 x 480 pixels

Storage media

CompactFlash (Types I & II); Micro Drive;
xD Picture Card

File formats

JPEG (SHQ/HQ/SQ); Raw (12-bit);
Raw+JPEG

Focus

Type TTL Phase Difference Detection
Modes Single AF; Continuous AF; Manual
Focus; Single AF + MF; Continuous AF +
MF; Focus Tracking
Focus Areas 11 points (fully biaxial)
Focus Selection Automatic; Manual
Detection Range EV-2-19 (at ISO 100)
Depth of Field Preview Yes

Exposure

Metering Type TTL with 49-zone
multipattern system
Metering Modes Digital ESP; Center-
weighted; Spot (Approx. 2%); Highlight
Spot; Shadow Spot
Exposure Modes Auto; Program AE (**P**);
Aperture Priority (**A**); Shutter Priority (**S**);
Manual (**M**)
ISO Modes Auto/Manual
ISO Range 100–3200 in ⅓ and 1EV steps
Exposure Compensation ±5EV in ⅓EV steps
Exposure Bracketing 3 or 5 frames in
⅓, ⅔, or 1EV steps
ISO Bracketing 3 frames in ⅓, ⅔, or
1EV steps

Shutter

Type Computerized focal-plane shutter
Shutter Speed 60 seconds–1/8000 sec.
(**P, A, S,** and **M**); Up to 30 minutes (Bulb)

Image stabilizer

Type Sensor shift
Compensation Range Approx. 5EV steps

Viewfinder

Type Eye-level TTL optical pentaprism
Coverage Approx. 100%.
Magnification Approx. x1.15 (with 50mm
lens set to infinity attached)
Eyepoint Approx. 20mm
Diopter Adjustment -3.0 to +1

Drive system

Modes Single; Sequential Shooting
Max. Frame Rate 5fps
Max. Frame Burst 17 frames (Raw);
Up to card capacity (JPEG HQ)
Self Timer 2 seconds; 12 seconds

Flash

Built-in Flash Yes
Guide Number 42ft/13m @ ISO 100
Modes Auto; Red-eye Reduction; Slow
Sync; Slow Sync with Red-eye Reduction;
2nd Curtain Slow Sync; Fill-in; Manual
(external flash only); Bracketing
(3 frames in ⅓, ½, or 1EV steps)
Sync Speed 1/250 sec.; 1/4000 sec. Super
FP mode
Flash Exposure Compensation ±3EV
in ½EV steps

Playback monitor

Type Multi-angle HyperCrystal LCD
Dimensions 2.5in (6.35cm)
Resolution 230,000 pixels
Coverage 100%
Languages English; German; French;
Spanish; Italian; Russian; Czech; Dutch;
Danish; Polish (other languages available
as Internet downloads)
Live View 100% field of view; Exposure
adjustment preview; White balance
adjustment preview; Gradation auto
preview; Optional gridline overlay; 5x, 7x,
and 10x magnification; MF/S-AF and AF

frame display; AF point display; Shooting
information; Histogram

Connections

External Interfaces USB 2.0
Video Out Jack Yes (NTSC or PAL)
Other Flash hotshoe; PC flash sync
terminal; Optional IR remote control;
DC-in

Dimensions

Size 5.6 x 4.6 x 2.9in (142 x 116 x 75mm)
Weight 1.8lb (800g)

Included software

Olympus Master 2.0

Power

Rechargeable 1500 mAh Li-ion battery
pack BLM-1

3 » ART FILTERS

The image processor in a camera takes the Raw image data from the sensor and, when shooting in JPEG, applies settings such as white balance, sharpness and contrast. When Olympus developed the TruePic III+ image processor for the E-30, other capabilities were added to its repertoire, the most arresting of which were the six "art filters" that recreated effects normally only possible in post production using graphics software.

The main benefit of processing images in-camera in this way is that the exposure can be calculated to maximize the effect of the filter at the time of capture. Since the E-30, Olympus has added to the range of effects its cameras can produce:

Pop Art Boosts the saturation of the colors in an image. Works well with bold, graphic subjects, such as architecture.

Gentle Sepia Applies a subtle brownish tone to black and white images that helps to give a photograph a timeless feel.

Pinhole Camera Darkens the corners of the image and boosts saturation. Keep your subject in the center of the image and the darkened corners will help to frame it.

Grainy Black & White Removes color, adds grain, and increases contrast. Suits images with atmosphere, such as stormy weather or urban landscapes.

Pale & Light Color Desaturates the colors in an image and reduces contrast. Helps to convey an ethereal, romantic feel.

Soft Focus Softens an image and, as with **Pale & Light Color**, adds a soft, romantic feel to an image.

Light Tone Reduces the intensity of the highlights and shadows in an image. Most useful when contrast is a problem, although noise might be increased in shadow areas.

Cross Process Shifts the colors in to create an effect similar to processing slide film in chemicals meant for print (negative) films.

Diorama Recreates the small depth of field encountered when shooting macro images, making your subject look like a miniature model.

Dramatic Tone Similar in effect to Light Tone, Dramatic Tone creates pseudo-HDR images by recovering detail from the shadow areas and subduing the highlights.

Pop Art

Gentle
Sepia

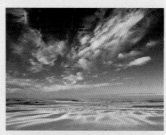

Pinhole
Camera

Grainy
Black &
White

Pale &
Light
Color

Soft
Focus

Light
Tone

Diorama

Settings

> *Focal length: 150mm*
> *Aperture: f/11*
> *Shutter speed: 4 sec.*
> *ISO: 100*

DETAIL ⌃

Longer focal length lenses are very useful for isolating interesting details in a scene. This pair of spectacles in the Bronte Parsonage Museum belonged to the Bronte sisters' father, Patrick. By using a long lens I was able to exclude modern information signs that detracted from the composition. The one problem I had was keeping the camera steady in this dimly lit room, although I was able to use a tripod. If I had not had this option, then I would have needed to use the maximum aperture setting on the lens, and increase the ISO sensitivity. Image stabilization would have been useful too.

Settings
> *Focal length: 30mm*
> *Aperture: f/8*
> *Shutter speed: 1/80 sec.*
> *ISO: 100*

LOOKING DOWN ⌃
Opportunities for making interesting photographs are all around you—the trick is to see them. Typically, most people look straight ahead, at eye-level, but it pays to occasionally look down at your feet, or up in the sky, to see what potential lies there. This clump of frost-covered grass caught my eye when out for a walk with my camera. Part of the scene was in shadow, and therefore very blue, which helped to create an interesting color contrast with the leaves that were lit by direct sunlight.

» OLYMPUS E-420 May 2008

OLYMPUS E-420 ⌃
With the Zuiko 25mm f/2.8 "pancake" lens.

With a number of Four Thirds digital SLR cameras already available, Olympus was keen to consolidate its line-up, with a new "level" of camera appearing between the entry-level E-xxx range and the pro-spec E-x models.

At first glance, the E-420 appeared very similar to its predecessor, the E-410. Indeed, many of the specifications were the same between the two cameras (as had been the case with the E-400/E-410), but there were still enough differences to make the launch of the E-420 another step in the evolution of the Four Thirds system.

One thing that didn't change was the size of the E-420: it retained the diminutive styling of the E-410 and gained only a few ounces in weight. Released at the same time as the E-420 was the Zuiko 25mm pancake lens, which, combined with the

camera, made for a small but powerful combination. The field of view of the 25mm lens is effectively a "standard" lens on a Four Thirds SLR, and with the discreet nature of the E-420 it made the pairing a tempting proposition for street and documentary photographers, as well as those bought up on "traditional" 35mm SLR cameras and standard prime lenses.

The headline difference between the E-410 and E-420, however, was the addition of contrast-detection autofocus. On the E-410, autofocus in Live View was only possible by "freezing" Live View temporarily, swinging the reflex mirror back into position, focusing the lens, and then switching back to Live View. This obviously all took time and could make using Live View rather frustrating. The addition of contrast-detection AF meant that the E-420's Live View could be used in a far more seamless way.

JARGON BUSTING: STANDARD LENS

A 50mm focal length is regarded as the "standard" focal length for full-frame digital and 35mm cameras because its angle of view closely matches that of our eyes, so images appear to look "natural." The Four Thirds equivalent is a 25mm focal length.

OLYMPUS E-420 "TWIN LENS" KIT »

E-420 versus E-410

As well as the significant technological inclusion of contrast-detection AF, the E-420 also boasted a number of additional key features when compared to the E-410:

Improved ergonomics Right hand grip subtly reshaped for improved comfort.

JARGON BUSTING: AUTOFOCUS

There are two main technologies used for autofocus systems: phase-detection and contrast-detection. Phase-detection is used mainly with optical viewfinders and contrast-detection with Live View. Phase-detection focusing is arguably less accurate than contrast-detection, but is faster and able to handle continuous focus tracking.

Face detection in Live View mode Up to eight faces could be detected and focused upon at any one time.

Built-in wireless flash control The E-420 could be used with Olympus's FL-50R and FL-36R flashes for wireless multi-flash photography, controlling up to three wireless flash groups independently.

2.7in LCD Utilizing HyperCrystal II technology, the E-420's LCD had a greater viewing angle (up to 176°), with a wider gamut for more true color representation. The size was also increased from the E-410's 2.5-inch screen.

Faster continuous shooting speed Frame rate increased from 3fps to 3.5fps.

Shadow adjustment technology Improved detail in shadow areas that would otherwise be underexposed.

3 » FLASH

When light levels drop and camera shake is a real possibility it is useful to have another source of light available. For those of us who don't have Hollywood's lighting resources, that extra light will most often come from a flash. Most, though not all, Four Thirds and Micro Four Thirds cameras are equipped with a built-in flash, and all have a hotshoe that allows you to fit an external flash unit.

One of the biggest problems with flash—especially built-in flashes—is their relative lack of power. Thanks to the inverse square law, the lighting capability of flash drops off rapidly with distance, so while we have all seen flashes popping in the crowd at a concert or sporting fixture, not one of these will be effective over the distance required, even if it does add to the theatricality of the event. Therefore, understanding both the limitations and potential of flash is necessary to use it effectively and creatively.

Guide numbers

The power of a flash is largely determined by its guide number (GN). This tells you the effective range of the flash in either meters or feet at a given ISO. This is important, as increasing the ISO will effectively increase the apparent power of the flash. To avoid confusion, most manufacturers use ISO 100 as the standard when quoting a guide number, but you should check carefully—some use ISO 200, which makes a flash appear more powerful.

The GN can either be used to determine the required aperture value for a subject at a given distance, or the effective range of the flash at a specified aperture. The formula to calculate both is respectively:

- GN/distance=aperture
- GN/aperture=distance

If a flash has a GN of 32 feet (10 meters) at ISO 100, for example, then at an aperture setting of f/8 (and at ISO 100), the effective flash distance is 4 feet (1.25 meters).

Fill-in flash

Most people think of using flash when there is little available light, but flash can also prove useful as a means of lowering contrast and "filling in" shadow areas in your subject. This is known as fill-in flash.

If you were to expose for a backlit subject, for example, the background would be overexposed, while exposing for the background would mean your subject would be grossly underexposed—possibly even turned into a silhouette.

Your camera's built-in flash or external flash can be used to even out the exposure of your shot, and in most cases, the

exposure should be calculated automatically by your camera so that the ambient light and the light from the flash are balanced. However, nothing is infallible and if your flash exposure is too bright or too weak, you can use flash exposure compensation.

Sync speed

When using flash, there is a limit to the fastest shutter speed you can use, which is known as the synchronization speed (often shortened to "sync speed"). The sync speed varies from camera to camera, but is often in the range of 1/160 sec. to 1/250 sec. You can use slower speeds than this, but not faster shutter speeds, as the shutter will not synchronize with the flash, resulting in a partially exposed image.

This limitation can be circumvented with the Olympus FL-36R and FL-50R, and the Panasonic DMW-FL360E and DMW-FL500E flashes, as these models can all be used in "Super FP" mode with compatible cameras. This allows shutter speeds that are faster than the sync speed to be used, which is achieved by pulsing the flash output to "build up" the exposure. This reduces the power of the flash (and therefore the effective distance), but it is a useful tool to have when fill-in flash is desired, but the ambient light requires a fast shutter speed.

SUPER FP

Using Super FP flash synchronization let me use my flash to provide fill-in light, despite the ambient exposure requiring a shutter speed of 1/500 sec. (below left). Without fill-in flash, the picture was too contrasty (below right).

Red-eye correction 👁

Red-eye is caused by direct flash when it is used to illuminate a face looking at the camera. The light from the flash bounces off the back of the subject's eye, picking up the color of the blood vessels there as it does so. The problem is exacerbated because flash tends to be used when light levels are naturally low, so the subject's pupils will be at their widest.

Red-eye correction uses a series of pre-flashes to make the subject's pupils contract, reducing the risk of the flash bouncing back out of the eye.

Slow sync ⚡SLOW

The fastest shutter speed that you can use with flash (without resorting to Super FP) is the sync speed, but you do not have to use this speed every time you use flash. As the sync speed is relatively fast, so you may find that the background areas that are not lit by flash will be seriously underexposed unless you use a longer shutter speed.

Slow sync is the technique of using a shutter speed that is suitable for exposing the background correctly, while the flash illuminates the foreground. The lower the ambient light levels, the longer the shutter speed will need to be, increasing the risk of camera shake. If the shutter speed drops to a level where you no longer feel you can handhold your camera successfully, mount the camera on a tripod instead. Slow sync flash works particularly well at dusk, when there is enough ambient light to make the background interesting.

SLOW SYNC **«**

Using a slow shutter speed of 1/10 sec. allowed me to retain detail in the dusk sky, while the flash illuminated the signpost.

Settings

> *Focal length: 24mm*
> *Aperture: f/9*
> *Shutter speed: 1/125 sec.*
> *ISO: 100*

FILL-IN ⌃

Using flash on a bright day allows you to control the contrast of shadow areas and—when shooting portraits—add a tiny sparkle to your subject's eyes.

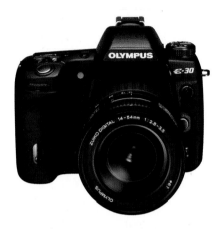

OLYMPUS E-30
A worthy competitor to digital SLR cameras
produced by Canon and Nikon.

Until the release of the E-30 there was a
gap in Olympus's camera line-up: at the
top of the range was the pro-orientated
E-3, while the E-420 and E-520 covered the
entry-level market. The E-30 was designed
to slot into the gap between the high- and
low-end models, providing an option for
experienced enthusiast photographers.

Sensor

Although designed as a mid-range digital
SLR camera, the E-30 trumped its pro-spec
stablemate E-3 in a number of areas, not
least with its 12.3-megapixel sensor, which
added two megapixels to the resolution
of the E-3. In keeping with all of Olympus's

Four Thirds cameras, the sensor had an
effective dust removal system, and the E-30
also benefited from the same sensor-based
image stabilization as the E-3.

On the level

In addition, the E-30 featured an electronic
"spirit level"—something the E-3 did not—
which used the camera's built-in dual axis
sensor to detect movement in both roll
(how far the camera rotates around the
lens axis) and pitch (how far the camera
tipped forward or back). This information
was then displayed as an easy-to-read level
gauge in the viewfinder, the top control
panel, and on the main LCD, so that the
camera could be leveled easily.

Autofocus

When he or she was using the viewfinder,
the photographer was able to use the same
11-point phase-detection system employed
by the E-3, but switching to Live View once
again saw the E-30 better its pro-spec
stablemate: contrast-detection focusing
allowed full-time autofocus in conjunction
with Live View.

To complement the Live View AF
capabilities, Olympus released a new lens,
the Zuiko 14–54mm f2.8–3.5 II, which was
designed to cope with the needs of the
contrast-detection focusing systems.

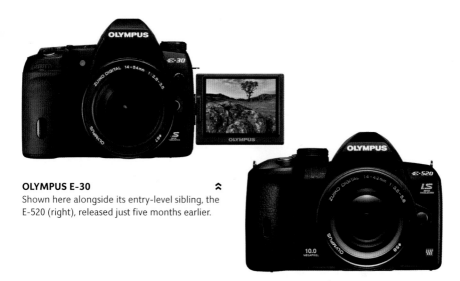

OLYMPUS E-30
Shown here alongside its entry-level sibling, the
E-520 (right), released just five months earlier.

Creativity

The press release announcing the arrival
of the E-30 declared that "We are the visual
generation" and, with this, Art Filters were
added to the E-30's already impressive list
of capabilities. These allowed a greater
choice to the photographer on how the
final photograph would look and, with
Live View activated, the filters could be
previewed in real time.

Another new feature was the ability to
create multiple exposures in-camera. This
was a comparatively easy trick to pull off
when shooting film, but less so when
shooting digital, without recourse to
image-editing software. It was only the
power of the E-30's TruePic III+ image

processor that this finally made this
possible. Up to four images could be
combined in this way, with the results
previewed on the E-30's LCD.

The final trick up the E-30's sleeve was
its ability to shoot in a variety of image
aspect ratios. As well as the standard 4:3
ratio, the photographer could also choose
from 16:9, 3:2, 5:4, 7:6, 6:5, 6:6, and 3:4
ratios, with JPEGs shot in any of these ratios
being trimmed and saved automatically.
Again, this function was most useful when
shooting using Live View, as the feedback
from the LCD allowed more accurate
composition than the viewfinder.

Sensor

Resolution 12.3 megapixels (effective)
Type 4:3 aspect ratio High Speed Live
MOS sensor

Image processor

TruePic III+

Body

Construction Materials Glass-fiber
reinforced plastics
Lens Mount Four Thirds

Image sizes

Maximum 4032 x 3024 pixels
Minimum 640 x 480 pixels

Storage media

CompactFlash (Types I & II); Micro Drive;
xD Picture Card

File formats

JPEG (SHQ/HQ/SQ); Raw (12-bit);
Raw+JPEG

Focus

Type TTL Phase Difference Detection;
Contrast-Detection system (Live View)
Modes Single AF; Continuous AF; Manual
Focus; Single AF + MF; Continuous AF + MF;
Focus Tracking (in Continuous AF mode)
Focus Areas 11 points (fully biaxial)
Focus Selection Automatic; Manual
Detection Range EV-2–19 (at ISO 100)
Depth of Field Preview Yes

Other information AF fine adjust available
(Up to 20 lenses can be registered)

Exposure

Metering Type TTL with 49-zone
multipattern system
Metering Modes Digital ESP; Center-
weighted; Spot (Approx. 2%); Highlight
Spot; Shadow Spot
Exposure Modes Programmed AE (**P**);
Aperture Priority (**A**); Shutter Priority (**S**);
Manual (**M**)
Art Filters Pop Art; Soft Focus; Pale & Light
Color; Light Tone; Grainy Film; Pinhole
ISO Modes Auto/Manual
ISO Range 200–3200 (Auto); 100–3200
in ⅓ or 1EV steps (Manual)
Exposure Compensation ±5EV in ⅓, ⅔,
or 1EV steps
Exposure Bracketing 3 or 5 frames in
±⅓, ⅔, or 1EV steps
ISO Bracketing 3 frames in ±⅓, ⅔, or
1EV steps

Shutter

Type Computerized focal-plane shutter
Shutter Speed 60 seconds–1/8000 sec.
(**P**, **A**, **S**, and **M**); Up to 30 minutes (Bulb)

Image stabilizer

Type Sensor shift
Compensation Range Approx. 5EV steps

Viewfinder

Type Eye-level single lens
Coverage Approx. 98%
Magnification Approx. x1.02 (with 50mm lens set to infinity)
Eyepoint Approximately 24.2mm
Diopter Adjustment -3.0 to +1

Drive system

Modes Single; Sequential Shooting
Max. Frame Rate 5fps (H)igh Speed; 1–4fps (L)ow Speed
Max. Frame Burst 14 frames (Raw); Compression ratio and resolution dependent (JPEG)
Self Timer 2 seconds; 12 seconds

Flash

Built-in Flash Yes
Guide Number 42ft/13m @ ISO 100
Modes TTL Auto (external flash only); Auto; Red-eye Reduction; Slow Sync; Slow Sync with Red-eye Reduction; 2nd Curtain Slow Sync; Fill-in; Manual; Bracketing (3 frames in ⅓, ½, or 1EV steps); Fill-in for exclusive flash (external flash only)
Sync Speed 1/250 sec.; 1/8000 sec. Super FP mode
Flash Exposure Compensation ±3EV in ⅓EV steps
Other Information Built-in flash and wireless flash control available (compatible with FL-50R and FL-36R flash guns)

Playback Monitor

Type Multi-angle HyperCrystal II LCD (color TFT)
Dimensions 2.7in (6.95cm)
Resolution 230,000 pixels
Coverage 100%
Languages English; German; French; Spanish; Italian; Russian; Czech; Dutch; Danish; Polish
Live View 100% field of view; Exposure adjustment preview; White balance adjustment preview; Gradation auto preview; Face detection preview; Perfect shot preview; Optional gridline overlay; 5x, 7x, and 10x magnification; MF/S-AF & AF frame display; AF point display; Shooting information; Histogram

Connections

External Interfaces USB 2.0
Video Out Jack Yes (NTSC or PAL)
Other Flash hotshoe; PC flash sync terminal; Optional IR remote control; DC-in

Dimensions

Size 5.6 x 4.2 x 2.9in (142 x 107 x 75mm)
Weight 1.6lb (730g)

Included software

Olympus Master 2.0; Olympus Studio 2 (trial version)

Power

Rechargeable 1500 mAh Li-ion battery pack BLM-1

3 » EXTERNAL FLASH

Both Olympus and Panasonic produce external flash for the Four Thirds and Micro Four Thirds systems, with their respective ranges covering small units that are useful for fill-in flash, all the way through to larger professional flashes, often with wireless capabilities.

The smallest units in the companies' flash ranges are the Olympus FL-20 and Panasonic DMW-220E respectively. Although neither of these flashes is particularly powerful, they are still useful for providing fill-in light, and are certainly more powerful (and therefore more versatile) than any of the built-in flashes on the Four Thirds cameras. Neither flash has wireless capability.

Panasonic DMW 220E ⌃
Fitted to a Panasonic Lumix G10.

	Olympus FL-20	Panasonic DMW-220E
Flash modes	TTL AUTO, AUTO, MANUAL	TTL AUTO, MANUAL
Guide number	65ft/20m @ ISO 100	72ft/22m @ ISO 100
Bounce angles	Not applicable	Not applicable
Dimensions (W x H x D)	2.2 x 3.78 x 1.1in (56 x 96 x 28mm)	2.4 x 3.85 x 1.81in (61 x 97.7 x 46.1mm)
Weight	2.61oz (74g)	3.91oz (111g)

Olympus FL-36R/Panasonic DMW-FL360E ⌃
The smaller of the two professional flashes produced by Olympus and Panasonic, the FL-36R/DMW FL360E are well-specified units. The headline feature is their wireless capability, which allows them to be used as a slave as part of a group of off-camera flash units.

OLYMPUS FL-50R ⌃
FL-50R flash shown attached to an Olympus E-30.

	Olympus FL-36R/ Panasonic DMW-FL360E	**Olympus FL-50R/ Panasonic DMW-FL500E**
Flash modes	TTL AUTO, AUTO, MANUAL, FP TTL AUTO, FP MANUAL, RC, SL AUTO, SL MANUAL	TTL AUTO, AUTO, MANUAL, FP TTL AUTO, FP MANUAL, RC, SL AUTO, SL MANUAL
Guide number	65ft/20m @ ISO 100 (at 12mm setting)	92ft/28m @ ISO 100 (at 12mm setting)
Bounce angles	90° up/7° down/ 90° right/180° left	90° up/7° down/ 90° right/180° left
Number of channels (wireless)	4 channels	4 channels
Group setting (wireless)	3 groups	3 groups
Wireless modes	TL AUTO, AUTO, MANUAL, FP TTL AUTO, FP MANUAL	TTL AUTO, AUTO, MANUAL, FP TTL AUTO, FP MANUAL
Dimensions (W x H x D)	2.64 x 3.74 x 4.25in (67 x 95 x 108mm)	3.07 x 5.55 x 4.21in (78 x 141 x 107mm)
Weight	9.17oz (260g)	13.6oz (385g)

COLOR ⌃

Color combinations can be described as analogous or complementary (there are other terms, but these are arguably the two most important). An analogous color combination involves colors that are close to each other in hue. In this photograph, the blues and greens of the leaves are analogous, and using analogous colors produces very harmonious and pleasing images.

Complementary color combinations are those that are opposite each other on a standard color wheel. In this shot, red and blue are the most evident complementary colors. Complementary color schemes are less relaxing, but have the effect of making the individual colors seem more vibrant than if used alone.

Settings
> *Focal length: 30mm*
> *Aperture: f/8*
> *Shutter speed: 1/1000 sec.*
> *ISO: 100*

JUST THE FACTS ⌃

One common mistake—especially with novices—is to try and include too much in the frame. If an image is too "busy," then it is easy for the actual subject of the picture to be lost amongst the clutter. To avoid this, consider carefully what the most important element of your scene is. Then find a viewpoint that minimizes distractions, possibly using a longer focal length or moving closer to isolate your subject.

In this shot, I deliberately shot from a low angle so that the eagle was against the blue sky, avoiding the extraneous and unwanted detail in the surrounding areas.

Chapter 4
MICRO FOUR THIRDS ARRIVES

4 MICRO FOUR THIRDS ARRIVES

The original promise of the Four Thirds system was that starting from scratch, rather than utilizing existing film camera technology, meant that cameras could be made smaller. To a certain extent this promise was fulfilled, but there was always a limit to the maximum possible size and weight reduction.

» MICRO FOUR THIRDS

Several of Olympus's Four Thirds digital SLR cameras could rightly claim to be the smallest and lightest cameras of their type when first released. However, the complex mirror assembly and pentaprism that are necessary to direct light through the lens and to the viewfinder both require space within the camera body. This would always limit the absolute minimum size of a Four Thirds camera, but the arrival of the Micro Four Thirds standard delivered a radical solution to this problem.

By ditching the mirror and pentaprism, and using Live View or an accessory viewfinder for composing images, instant size and weight savings could be made. As an added benefit, the loss of the mirror meant that the rear of the lens could be brought closer to the sensor, enabling the design of smaller and lighter lenses as well.

For this reason, the lens mount is different between the two standards and Micro Four Thirds lenses cannot be used on Four Thirds cameras. Four Thirds lenses can be used on Micro Four Thirds cameras, however, and they will retain full autofocus and exposure capabilities if used with a specific lens adapter.

Panasonic were first off the blocks with a Micro Four Thirds camera when they released the DMC-G1 in October 2008. The camera's design was clearly influenced by conventional digital SLR styling, although it relied on an electronic, rather than optical, viewfinder.

DESIGN «
Olympus Micro Four Thirds concept model.

OLYMPUS PEN EE »
ADVERTISEMENT
A camera for young ladies
from the 1960s.

Although the G1 was successful, it arguably lacked the "spark" that was needed to get people excited about the new format. Instead, it was left to Olympus to generate interest and excitement in Micro Four Thirds, which the company achieved by looking to its past.

Prior to digital photography, Olympus had a reputation for producing small, lightweight cameras and one of its most popular models was the Olympus PEN, released in 1959. The PEN was a half-frame camera that was able to squeeze twice as many photos onto a roll of 35mm film as a "normal" 35mm camera. It was also one of the smallest cameras available that used 35mm film and was so successful that its final iteration—the PEN EF—was still being produced in the early 1980s.

Given such a history, it is therefore fitting that Olympus harked back to the success of the PEN with their first Micro Four Thirds camera, the E-P1. The clean design was a clear nod to its illustrious forebear, and it also used a sensor that was approximately half the size of those used in a full-frame digital camera, making it a digital "half-frame" camera. Thanks to some clever marketing, the E-P1 was an instant success and the Micro Four Thirds standard was truly born.

4 » PANASONIC LUMIX DMC-G1 October 2008

PANASONIC LUMIX DMC-G1 ⌃
With its flash raised, ready for action.

Despite its somewhat conservative look, Panasonic's Lumix DMC-G1 was a truly revolutionary camera, if for no other reason than it was the first Micro Four Thirds camera to market. It also showed clearly Panasonic's intentions for its future camera line-up.

The relatively traditional shape of the G1 was an astute move on Panasonic's behalf, as designing the camera to look like a shrunken digital SLR meant that it would appeal to potential digital SLR buyers. At the same time, the small size was designed to attract those who would feel intimidated by a larger, conventional digital SLR and would otherwise buy a compact digital camera instead.

Live View

To an experienced digital SLR user, the biggest difference between the G1 and a larger camera came when looking through the viewfinder. Although the viewfinder "hump" on the top of the camera looked as though it contained a conventional pentaprism, hidden underneath was an electronic viewfinder (EVF).

Unlike the LCD on the back of the G1, the viewfinder used LED-illuminated Direct-view LCOS (Liquid Crystal On Silicon) technology. This is the same technology used in Panasonic's high-end video cameras, so to find it in a consumer product showed Panasonic's faith in the Micro Four Thirds system.

The advantage over an LCD came in terms of resolution and color: without either of these an EVF looks like a cheap replacement for an optical viewfinder. Although the G1's EVF looked coarse and grainy in low-light, for most situations it performed better than expected, and it was generally agreed that it justified the switch from a more traditional, optical viewfinder.

In a nod to the digital SLR user, the EVF showed all the current shooting settings, although it was also possible to show other available options. Another neat touch was that the layout of the EVF matched the LCD, so it was a seamless process when you switched from one to the other.

PANASONIC LUMIX DMC-G1 ⌃
The large, 3-inch multi-angle LCD.

For those coming from a compact digital camera, the natural approach to using the G1 would be to view and compose images using the rear LCD. Again, Panasonic did not disappoint, with a high-resolution, multi-angle LCD that could be tilted and rotated, as well as turned inward to protect it when not in use.

Focus

Most mirrorless cameras use a contrast-detection autofocus system, which is more accurate (but significantly slower) than the phase-detection system found in digital SLRs. The G1 is no exception, although it was important that Panasonic got the contrast-detection system right: the autofocus simply could not be seen to hamper the camera's handling in any way.

Fortunately, this was another area that Panasonic's engineers got right first time. The new Venus HD image processor inside the G1 was more than powerful enough to keep pace with the contrast-detection autofocus. In turn, the contrast-detection AF performed in a similar fashion to a phase-detection system, with the added bonus that the AF point could be moved anywhere around the image—something that is impossible to implement with a phase-detection system.

Perhaps the final proof—if proof was needed—that Panasonic got the design of the G1 right was that, since its release, the company has not produced another "standard" Four Thirds camera. The future, for Panasonic at least, was definitely going to be Micro Four Thirds.

Sensor

Resolution 12.1 megapixels (effective)
Type 4:3 aspect ratio Live MOS sensor

Image processor

Venus HD Engine

Body

Construction Materials Plastic
Lens Mount Micro Four Thirds

Image sizes

Maximum 4000 x 3000 pixels
Minimum 1920 x 1080 pixels

Storage media

SD memory card (compatible with SDHC)

File formats

JPEG (Standard/Fine); Raw (12-bit);
Raw+JPEG

Focus

Type Contrast-detection system
Modes Single AF; Continuous AF; Manual
Focus; Face Detection; AF Tracking
Focus Areas 1 and 23 points
Focus Selection Automatic; Manual
Detection Range EV0–18 (at ISO 100)
Depth of Field Preview No

Exposure

Metering Type TTL with 144-zone
multipattern system
Metering Modes Intelligent Multiple;
Center-weighted; Spot
Exposure Modes Programmed AE (**P**);
Aperture Priority (**A**); Shutter Priority (**S**);
Manual (**M**)
Advanced Scene Modes Portrait (Normal,
Soft Skin, Outdoor, Indoor, and Creative);
Scenery (Normal, Nature, Architecture,
and Creative); Sports (Normal, Outdoor,
Indoor, and Creative); Close-up (Flower,
Food, Objects, and Creative); Night
Portrait (Night Portrait, Night Scenery,
Illuminations, and Creative)
Scene Modes Sunset; Party; Baby 1 & 2; Pet
ISO Modes Auto/Manual; Intelligent ISO
ISO Range 100–3200
Exposure Compensation ±3EV in ⅓EV steps
Exposure Bracketing 3, 5, or 7 frames ±2EV
in ⅓ or ⅔EV steps

Shutter

Type Computerized focal-plane shutter
Shutter Speed 60 seconds–1/4000 sec.;
Up to 4 minutes (Bulb)

Viewfinder

Type Electronic Live View Finder
Coverage 100%
Resolution Approx. 1,440,000 pixels
Magnification x1.4
Eyepoint Approx. 17.5mm
Diopter Adjustment -4.0 to +4

Drive system

Modes Single; Sequential Shooting (H)igh
Speed; Sequential Shooting (L)ow Speed
Max. Frame Rate 3fps (H); 2fps (L)
Max. Frame Burst 7 frames (Raw);
Compression ratio and resolution
dependent (JPEG)
Self Timer 2 seconds; 10 seconds;
10 seconds (3 images)

Flash

Built-in Flash Yes
Guide Number 36ft/11m @ ISO 100
Modes Auto; Auto Red-eye Reduction;
Forced On; Forced On Red-eye
Reduction; Slow Sync; Slow Sync Red-eye
Reduction; Forced Off; 1st Curtain Sync;
2nd Curtain Sync
Sync Speed 1/160 sec.
Flash Exposure Compensation ±2EV in
⅓EV steps

Playback monitor

Type Low temperature Polychrystalline
TFT LCD
Dimensions 3in (7.6cm)
Resolution 460,000 pixels
Coverage 100%
Languages Japanese; English; German;
French; Italian
Live View 100% field of view; Optional
guidelines; Real-time histogram

Connections

External Interfaces USB 2.0
Video Out Jack No
Other Flash hotshoe

Dimensions

Size 4.88 x 3.3 x 1.77in (124 x 84 x 45mm)
Weight 0.8lb (385g)

Included software

PHOTOfunSTUDIO 2.1 E; SILKYPIX
Developer Studio 3.0 SE

Power

Rechargeable 1250 mAh Li-ion DMW-
BLB13PP battery pack; Dummy battery
DMW-DCC3 for AC power connection

JPEG

JPEG is short for "Joint Photographic Experts Group," a reference to the original software team that developed what is arguably the most successful image file format ever created. JPEG images are found everywhere, from website use to word-processing packages, and can be identified by the extension .JPG, or occasionally .JPEG.

One of the reasons behind its success is that JPEG files sizes tend to be reasonably small, which, in the early days of the Internet meant they were ideal when data bandwidth was at a premium. The small file sizes are achieved by compressing the image data, but it is important to note that this compression works by reducing the fine detail in the image: the greater the compression, the greater the loss of detail, but the smaller the file size.

All Four Thirds and Micro Four Thirds cameras offer JPEG as an image format choice, often with different levels of compression. Once an image has been saved to the memory card it is impossible to recover detail lost due to compression, so a compromise has to be made between image quality and memory card space. If you have a high-capacity memory card, or the facility to regularly copy your images to another storage device, it is worth using the highest quality setting you can.

When a JPEG image is captured, the various image parameters set on your camera are applied, which includes white balance, sharpness, contrast, and color settings. Although some of these parameters can be altered in post-production, there is the risk that the picture will quickly be degraded and further image quality lost.

Raw

A Raw file is the image data captured by the digital sensor. No processing is applied to Raw files, which makes it a less "user-

JPEG COMPRESSION »
A heavily compressed JPEG file. At 100% magnification, the blocky artifacts caused by the compression are very visible.

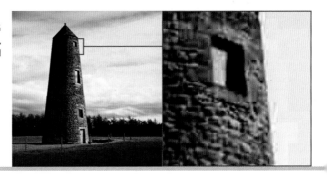

ADOBE LIGHTROOM »
Lightroom is a renowned third-party Raw conversion and image-editing program.

friendly" format when compared to a JPEG: dedicated Raw file conversion software is needed to decode the data so it can be saved in a more widely used format. Because the data in a Raw file is more comprehensive than a JPEG, Raw files also take up considerably more space on the memory card.

There is no Raw file format standard, so one manufacturer's Raw files will differ from another's—even Raw files from the same manufacturer, but in different camera models, may differ slightly. This means that Raw software needs to be updated on a regular basis to avoid it becoming out of date. At the time of writing, Olympus uses the extension .ORF for its Raw files, while Panasonic uses .RW2.

Because a Raw file is essentially an image that has not been processed, it can look slightly disappointing when first viewed on screen. However, this is the beauty of the Raw file concept. Because your camera has applied no processing, you are free to "interpret" the Raw file yourself. A Raw file has potential in the way that a JPEG does not, and as you never actually overwrite a Raw with your adjustments, you are free to return to it and re-interpret it as often as you like.

All of this makes Raw files more time-intensive than shooting JPEGs: a JPEG image is ready when it has been saved to the card, but a Raw file requires post-production at a later date. Which approach appeals is very much a personal choice, but for photographers who want to wring the very best out of their camera, Raw files are worth the inconvenience.

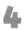

4 » OLYMPUS E-620 March 2009

Olympus E-620 ⤊
Proof that good things come in small packages.

It is often the case that features found on high-end cameras eventually filter down the manufacturer's range, and Olympus's E-620 was a case in point.

Following hot on the heels of the E-30, it shared many of the features of the pro-spec camera, but in a more compact and less expensive package. Of those features that were omitted, few would be particularly detrimental to the camera's overall performance, which made the E-620 something of a bargain.

E-620 versus E-30

Exposure E-620's maximum shutter speed is 1/4000 sec. (E-30 is 1/8000 sec.) and the multiple exposure feature is restricted to two images.

Shooting AF restricted to a 7-point system, compared to the E-30's 11-point focusing system. Maximum shooting rate drops from 5fps to 4fps.

Flash E-620 has slower flash sync speed (1/180 sec., compared to 1/250 sec.) and no PC flash sync socket.

Body The E-620 is smaller and approximately 6.35oz (180g) lighter; improvements made to the LCD (luminance increased); one control dial compared to two on the E-30; reduced viewfinder coverage (95% compared to 98% on the E-30); no digital level gauge; no DC socket.

Settings

> *Focal length: 18mm*
> *Aperture: f/5.6*
> *Shutter speed: 1/125 sec.*
> *ISO: 100*

EYES ⌃

Portraits are especially striking when the subject is looking directly at the camera. To achieve this you must engage with your subject. This is obviously easier when you know the person, but far more difficult when meeting people as you travel. Learning a few words of the local language can work wonders, even if it is just a friendly word of greeting, or "please" and "thank you."

Sensor

Resolution 12.3 megapixels (effective)
Type 4:3 aspect ratio High Speed Live MOS sensor

Image processor

TruePic III

Body

Construction Materials Plastic
Lens Mount Four Thirds

Image sizes

Maximum 4032 x 3024 pixels
Minimum 640 x 480 pixels

Storage media

CompactFlash (Types I & II); Micro Drive; xD Picture Card

File formats

JPEG (SHQ/HQ/SQ); Raw (12-bit); Raw+JPEG

Focus

Type TTL Phase Difference Detection; Contrast-detection system (Live View mode)
Modes Single AF; Continuous AF (not available in Live View mode); Manual Focus; Single AF + MF; Continuous AF + MF; Focus Tracking (in Continuous AF mode); Face Detection (Live View mode)
Focus Areas 5 points biaxial (TTL Phase Difference); 7 points (Live View mode)
Focus Selection Automatic; Manual
Detection Range EV-1-19 (at ISO 100)
Depth of Field Preview No
Other information AF fine adjust available

Exposure

Metering Type TTL with 49-zone multipattern system
Metering Modes Digital ESP; Center-weighted; Spot (Approx. 2%); Highlight Spot; Shadow Spot
Exposure Modes Auto; Program (**P**); Aperture Priority (**A**); Shutter Priority (**S**); Manual (**M**); Scene Program; Scene Select
Scene Program Modes Portrait; Landscape; Macro; Sport; Night and Portrait
Scene Select Modes Children; High Key; Low Key; DIS mode; Nature Macro; Candle; Sunset; Fireworks; Documents; Panorama (only available when using Olympus xD Picture Card); Beach and Snow; Underwater Wide; Underwater Macro
Art Filters Pop Art; Soft Focus; Pale & Light Color; Light Tone; Grainy Film; Pinhole
ISO Modes Auto/Manual
ISO Range 200-3200 (Auto); 100-3200 (Manual)
Exposure Compensation ±5EV in ⅓, ⅔, or 1EV steps
Exposure Bracketing 3 frames in ±⅓, ⅔, or 1EV steps
ISO Bracketing 3 frames in ±⅓, ⅔ or 1EV

Shutter

Type Computerized focal-plane shutter
Shutter Speed 60 seconds-1/4000 sec. (**P, A, S,** and **M**); Up to 30 minutes (Bulb)

Image stabilizer

Type Sensor shift
Compensation Range Approx. 4EV steps

Viewfinder

Type Eye-level single-lens reflex
Coverage Approx. 95%.
Magnification Approx. x0.96 (with 50mm lens set to infinity)
Eyepoint Approx. 18mm
Diopter Adjustment -3.0 to +1

Drive system

Modes Single; Sequential Shooting (H)igh Speed; Sequential Shooting (L)ow Speed
Max. Frame Rate 4fps (H)igh Speed; 1–3fps (L)ow Speed
Max. Frame Burst 5 frames (Raw); Compression ratio and resolution dependant (JPEG)
Self Timer 2 seconds; 12 seconds

Flash

Built-in Flash Yes
Guide Number 39ft/12m @ ISO 100
Modes Auto; Red-eye Reduction; Red-eye Reduction Slow Sync; Slow Sync 1st Curtain; Slow Sync 2nd Curtain; Fill-in; Manual (¼, ⅟₁₆, or ⅟₆₄ power); Bracketing (3 frames in ⅓, ½ or, 1EV steps)
Sync Speed 1/180 sec.
Flash Exposure Compensation ±3EV in ⅓, ½, or 1EV steps
Other Information Built-in flash and wireless flash control available

Playback monitor

Type HyperCrystal LCD (color TFT)
Dimensions 2.7in (6.95cm)
Resolution 230,000 pixels

Coverage 100%
Languages English; French; German; Spanish; Italian; Japanese; Korean; Traditional Chinese; Simplified Chinese; Russian; Czech; Dutch; Danish; Polish; Portuguese; Swedish; Norwegian; Finnish; Croat; Slovenian; Hungarian; Greek; Slovakian; Turkish; Latvian; Estonian; Lithuanian; Ukrainian; Serbian; Bulgarian; Rumanian; Indonesian; Malay; Thai
Live View 100% field of view; Exposure adjustment preview; White balance adjustment preview; Gradation auto preview; Face detection preview; Perfect shot preview; Optional grid line overlay; 5x, 7x & 10x magnification; MF/S-AF & AF frame display; AF point display; Shooting information; Histogram; IS Activating mode

Connections

External Interfaces USB 2.0
Video Out Jack No
Other Flash hotshoe; Optional RM-UC1 remote control; Optional HLD-5 battery grip

Dimensions

Size 5.11 x 3.7 x 2.36in (129 x 94 x 59mm)
Weight 1.04lb (472g)

Included software

Olympus Master 2.0; Olympus Studio 2 (trial version)

Power

Rechargeable 1200 mAh Li-ion battery pack BLS-1

LIGHTING ⌃

The direction of the light you use will determine the esthetic qualities of your photographs. A particularly attractive lighting setup is side-lighting, which helps to reveal texture and give your subject a sense of shape and form. One potential problem with side-lighting is contrast, and in this image, even though the subject was lit, the background was

HUMOR ⌃

Creating a "funny" photograph is a difficult thing to do—or at least making a photograph that is universally funny is: what one person finds funny may leave another person cold. One aspect of humor that seems to work well is juxtaposition. This is when one element in the picture somehow relates to another element in an unusual way. At the time I made this picture I was struck by the fact that the climber was literally—and metaphorically—ascending a rock "face."

 » OLYMPUS E-450 March 2009

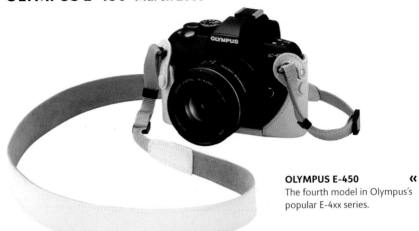

OLYMPUS E-450 **«**
The fourth model in Olympus's popular E-4xx series.

The Olympus E-450 retained the overall design and style of the E-410 and E-420, making it yet another gentle evolution in the E-4xx range. However, inside, a few key developments had been introduced:

Improved image processor Olympus's TruePic processor was upgraded to version "III+" for improved noise reduction and enhanced image characteristics such as contrast and color.

Three new Art Filters Pop Art (for creating images with bold colors), Soft Focus (for a more romantic touch), and Pinhole (replicating the characteristics of a pinhole camera).

Improved image buffer Buffer size increased to eight Raw files (compared to the E-420's six).

LCD Screen luminance characteristics improved in comparison to the E-420.

SOFTWARE **»**
The E-450 came with Olympus Master 2.0, a useful piece of software that helps you organize and edit your photos.

› Organizing your photos

With ten images it is easy to find the one you want, but when you have thousands of pictures it is far more difficult. It doesn't take long for an image collection to get out of hand.

The first task when it comes to organization is to decide on a logical naming system for your images. Although the camera creates a file name, it is best not to rely on this as the naming system will eventually reset and you could end up with multiple files with the same name.

It is a good idea to sort your images into folders, again using a logical system. One method is to divide the folders into categories, so you have a folder called "Animals," for example. This could then contain further folders, with more specific categories, such as "Dogs" and "Cats," and so on. Although this takes a lot of work initially, this will be repaid by the ease with which you can find specific images.

Sensor
Resolution 10 megapixels (effective)
Type 4:3 aspect ratio High Speed Live
MOS sensor

Image processor
TruePic III+

Body
Construction Materials Plastic
Lens Mount Four Thirds

Image sizes
Maximum 3648 x 2736 pixels
Minimum 640 x 480 pixels

Storage media
CompactFlash (Types I & II); Micro Drive;
xD Picture Card

File formats
JPEG (Super Fine/Fine/Normal/Basic);
Raw (12-bit); Raw+JPEG

Focus
Type TTL Phase Difference Detection
(Optical Viewfinder); Contrast-detection
system (Live View)
Modes Single AF; Continuous AF (not
available in Live View mode); Manual
Focus; Single AF + MF; Continuous AF + MF
(not available in Live View mode); Focus
Tracking (in Continuous AF mode)
Focus Areas 3 points (TTL Phase
Difference); 11 points (Contrast-detection)

Focus Selection Automatic; Manual
Detection Range EV-1-19 (at ISO 100)
Depth of Field Preview Yes

Exposure
Metering Type TTL with 49-zone
multipattern system
Metering Modes Digital ESP; Center-
weighted; Spot (Approx. 2%); Highlight
Spot; Shadow Spot
Exposure Modes Auto; Program (**P**);
Aperture Priority (**A**); Shutter Priority (**S**);
Manual (**M**); Scene Modes
Scene Program Modes Portrait; Landscape;
Macro; Sport; Night and Portrait
Scene Select AE Modes Art Filter (Pop Art/
Soft Focus/Pin Hole); Portrait; Landscape;
Landscape and Portrait; Night Scene; Night
and Portrait; Children; Sport; High Key;
Low Key; DIS mode; Macro; Nature Macro;
Candle; Sunset; Fireworks; Documents;
Panorama; Beach and Snow
Art Filters Pop Art; Soft Focus; Pinhole
ISO Modes Auto/Manual
ISO Range 100–1600 (Auto);
100–1600 (Manual)
Exposure Compensation ±5EV in ⅓EV steps
Exposure Bracketing 3 frames in ±⅓, ⅔, or
1EV steps

Shutter
Type Electronically-controlled focal-plane
Shutter Speed 60 seconds–1/4000 sec.;
Up to 30 minutes (Bulb)

Viewfinder

Type Eye-level single-lens reflex
Coverage Approx. 95%.
Magnification Approx. x0.92 (with 50mm lens set to infinity)
Eyepoint Approx. 14mm
Diopter Adjustment -3.0 to +1

Drive system

Modes Single; Sequential Shooting
Max. Frame Rate 3.5fps
Max. Frame Burst 8 frames (Raw); Compression ratio and resolution dependent (JPEG)
Self Timer 2 seconds; 12 seconds

Flash

Built-in Flash Yes
Guide Number 39ft/12m @ ISO 100
Modes Auto; Red-eye Reduction; Red-eye Reduction Slow Sync; Slow Sync 1st Curtain; Slow Sync 2nd Curtain; Fill-in
Sync Speed 1/180 sec.; 1/4000 sec. Super FP mode
Flash Exposure Compensation ±3EV in ½EV steps

Playback monitor

Type HyperCrystal LCD (color TFT)
Dimensions 2.7in (6.95cm)
Resolution 230,000 pixels
Coverage 100%
Languages English; German; French; Spanish; Italian; Russian; Czech; Dutch; Danish; Polish; Choice of one further language from 15 downloaded from the Internet
Live View 100% field of view; Exposure adjustment preview; White balance adjustment preview; Gradation auto preview; Face detection preview; Perfect shot preview; Optional grid line overlay; 7x & 10x magnification; MF/S-AF & AF frame display; AF point display; Shooting information; Histogram

Connections

External Interfaces USB 2.0
Video Out Jack No (Multi-use USB for Video Out)
Other Flash hotshoe

Dimensions

Size 5.1 x 3.6 x 2.1in (129.5 x 91 x 53mm)
Weight 0.8lb (380g)

Included software

Olympus Master 2.0; Olympus Studio 2 (trial version)

Power

Rechargeable 1150 mAh Li-ion battery pack BLS-1

» PANASONIC LUMIX DMC-GH1 March 2009

PANASONIC LUMIX DMC-GH1 ☆
With optional DMW-MS1 microphone.

When it launched the GH1, it was clear that Panasonic had taken an "if it isn't broken, don't fix it" approach to the camera's design. Visually, there was very little difference between the GH1 and its predecessor, the G1, although the addition of an HD symbol and a built-in stereo microphone gave a strong hint as to the biggest difference between the two.

The creative HD hybrid

The GH1 contained a newly developed 12.1-megapixel Live MOS sensor that was capable of full-HD (High Definition) movie recording. It could also record still images in four different aspect ratios (4:3, 3:2, 16:9, and 1:1), each one maintaining the same angle of view. As the sensor has a slightly larger surface area than standard Four Thirds units, the first three aspect ratios had a similar pixel count.

The sensor was aided by Panasonic's improved Venus Engine HD image processor, which used two CPUs to improve the speed of the data throughput, as well as tasks such as noise reduction.

The Venus Engine also had the power to compress HD video data and output the results using the AVHCD video format. This improved over the older Motion JPEG format by having a better compression ratio, so that almost twice as much video could be shot and stored on a memory card. The GH1 was capable of shooting full-HD movies with a 1920 x 1080 pixel resolution at 24fps or, for a small drop in resolution, HD 1280 x 720 pixels at 60fps. A dedicated movie recording button also featured, so that shooting could begin immediately, without the need to turn a mode dial.

Choices

To complement movie shooting, Panasonic released the GH1 with the Lumix G Vario HD 14–140mm lens, which supported the fast contrast-detection system first seen on the G1 and suppressed mechanical noise during the AF function to avoid the lens interfering with movie soundtracks.

Like the G1, the GH1 also came in two colors: Authentic Black or Active Red. Naturally, this did not affect the quality of the images shot with the camera, but it was a popular move on Panasonic's behalf. Micro Four Thirds owners, it seemed, like to think of themselves as individuals.

Face Detection

An additional benefit that Live View cameras have over their viewfinder-only cousins is Face Detection. The ability to recognize a face means a camera can immediately prioritize this over other features in a scene, so that once a face has been detected, the focus, exposure, and even the picture style can be optimized for the best results.

A number of Four Thirds cameras released prior to the GH1 had Face Detection, but the GH1's system had the ability to actually *recognize* a specific subject's face, so that once an individual had been registered with the camera (prior to shooting) the focus could be prioritized on this face—ideal for picking out one person in a crowd, for example.

MOVIE RECORDING »
The red, one-touch video button made it far easier to begin recording movies.

Sensor

Resolution 12.1 megapixels (effective)
Type 4:3 aspect ratio CCD sensor
17.3 x 13.0mm effective area

Image processor

Venus Engine HD

Body

Construction Materials Plastic
Lens Mount Micro Four Thirds

Image sizes

Maximum 4000 x 3000 pixels
Minimum 1504 x 1504 pixels

Storage media

SD Memory card (compatible with SDHC)

File formats

Still Images JPEG (Fine; Normal); Raw
(12-bit); Raw+JPEG
Movie Mode AVCHD; Motion JPEG

Focus

Type Contrast AF
Modes Single AF; Continuous AF; Manual
Focus; Face Detection; AF Tracking; Pre AF
AF+MF, MF Assist
Focus Areas 1 and 23 area focusing
Focus Selection Automatic; Manual
Detection Range EV0–18 (at ISO 100)
Depth of Field Preview No

Exposure

Metering Type 144-zone multipattern
system
Metering Modes Intelligent Multiple;
Center-weighted; Spot
Exposure Modes Programmed AE (**P**);
Aperture Priority (**A**); Shutter Priority (**S**);
Manual (**M**)
Advanced Scene Modes Portrait (Normal,
Soft Skin, Outdoor, Indoor, and Creative);
Scenery (Normal, Nature, Architecture, and
Creative); Sports (Normal, Outdoor, Indoor,
and Creative); Close-up (Flower, Food,
Objects, and Creative); Night Portrait (Night
Portrait, Night Scenery, Illuminations, and
Creative); SCN (Sunset, Party, Baby 1 & 2,
and Pet)
Scene Modes (Movie mode) Portrait;
Scenery; Sports; Low Light; Close-up
(Flower, Food, Objects, and Macro); SCN
(Sunset, Party, and Portrait)
ISO Modes Auto/Manual; Intelligent ISO
ISO Range 100–3200
Exposure Compensation ±3EV in ⅓EV steps
Exposure Bracketing 3, 5, or 7 frames, ±2 in
⅓ or ⅔EV steps

Shutter

Type Focal-plane shutter
Shutter Speed 60 seconds–1/4000 sec.;
Up to 4 minutes (Bulb)

Viewfinder

Type Electronic Live View Finder
Coverage 100%
Resolution Approx. 1,440,000 pixels
Magnification x1.4
Eyepoint Approx. 17.5mm
Diopter Adjustment -4.0 to +4.0

Drive system

Modes Single; Sequential Shooting
Max. Frame Rate 3fps
Max. Frame Burst 7 frames (Raw/TIFF);
Up to card capacity (JPEG resolution and
compression dependent)
Self Timer 2 seconds; 10 seconds;
10 seconds (3 images)

Flash

Built-in Flash Yes
Guide Number 36ft/11m @ ISO 100
Modes Auto; Auto–Red-eye Reduction;
Forced On; Forced On–Red-eye
Reduction; Slow Sync; Slow Sync–
Red-eye Reduction; Forced Off
Sync Speed 1/160 sec.
Flash Exposure Compensation ±2EV
in ⅓EV steps

Movie recording

Recording Format AVCHD; Motion JPEG
AVHCD Modes Lite Full HD 1920 x 1080;
HD 1280 x 720 60p/50p
Motion JPEG Modes QVGA 320 x 240; VGA
640 x 480; WVGA 848 x 480; HD 1280 x 720

Frame Rate 30fps (NTSC); 25fps (PAL)
Maximum recording time Up to 210
minutes using AVHCD at SH quality

Playback monitor

Type Low temperature Polycrystalline
TFT LCD
Dimensions 3in (7.6cm)
Resolution 460,000 pixels
Coverage 100%
Languages English; German; French;
Italian; Japanese
Live View 2x and 4x magnification; Extra
Optical Zoom; Real-time histogram;
Guidelines (3 patterns)

Connections

External Interfaces USB 2.0 (12Mb/s);
HDMI Type C mini connector; 2.5mm
microphone stereo mini jack
Video Out Jack No
Other Flash hotshoe

Dimensions

Size 4.88 x 3.54 x 1.77in (124 x 90 x 45mm)
Weight 13.58oz (385g)

Included software

PHOTOfunSTUDIO 3.1 HD edition;
SILKYPIX Developer Studio 3.0 SE

Power

Rechargeable 1250 mAh Li-ion battery;
Dummy battery for AC adapter

RIGHT TIME, RIGHT PLACE ⌃

Sometimes blind luck has a part to play in photography, but the more often you carry your camera around with you, the luckier you will become. This photograph was taken while I was waiting for someone. I noticed gulls around this sculpture and took a couple of quick grab shots. It was only when I reviewed them at home that I realized that the "wings" of the sculpture resembled wings and that the foreground gulls look as though they were once part of the piece. After some research I was further gratified to discover that the sculpture, by Charles Normande, was called *Tails of Flight*!

Settings
› *Focal length: 15mm*
› *Aperture: f/14*
› *Shutter speed: 1/160 sec.*
› *ISO: 320*

FILLING THE FRAME »

A common mistake when it comes to composing your images is to include too much space around your subject. If the space is sufficiently large and open, your subject can become "lost" in the picture space and cease to be the center of attention in the photo. Getting in close to your subject will also help add a sense of intimacy to the photo. However, getting in close means you will need to be very precise in your focusing, so it is important to decide where the sharpest point of the picture should be and move the focus point to this accordingly.

Chapter 5
PEN FRIENDS

5 PEN FRIENDS

Although Panasonic was the first company to market a Micro Four Thirds camera, Olympus arguably had a bigger impact when it launched the E-P1; the first of its "digital PEN" camera models.

» OLYMPUS E-P1 July 2009

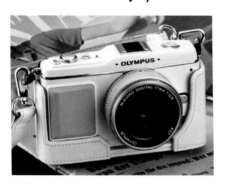

STYLISH ⌄
Olympus stressed the retro-chic aspect of the E-P1.

Reminiscent of the company's PEN range of 35mm film cameras, the Olympus E-P1 was a pleasing mix of retro design and hi-tech components, which was clearly designed to make ownership of the camera a very personal experience.

The camera was available in silver or white (a pleasant change from the ubiquitous black), with a range of matching accessories, including leather cases and straps, which helped complete the "retro-chic" look. Capitalizing on this, Olympus advertised the E-P1 in a wide range of influential lifestyle magazines, as well as the photographic press. The E-P1 didn't just look good, either: aluminum and stainless steel were used in its construction, which were expensive materials for a camera of this type.

Internally, the E-P1 borrowed a number of features from its digital SLR siblings; the Art Modes of the E-30, for example, with the same advantage that shooting in Raw and JPEG simultaneously allowed the JPEG to be recorded with the Art Mode applied, but the Raw file was left untouched.

Compromises

Given its small size, the E-P1 was perhaps inevitably going to be compromised in some areas, and the most notable of these was the total reliance on the rear LCD screen. Although Olympus offered the VF-1 optical viewfinder for the E-P1, this was only for use with the 17mm f/2.8 "pancake" lens that was available separately or as part of a kit. Also missing from the E-P1 was a built-in flash, although the camera's hotshoe offered full compatibility with all Four Thirds flashes.

Processing power

The 12.3-megapixel sensor used in the E-P1 was essentially the same as that found in the Olympus E-30 and E-620. However, the anti-aliasing filter was lighter than those used in previous Olympus sensors, which helped to increase the apparent resolution of images shot with the E-P1, while the risk of moiré in high-frequency subjects was reduced through the "next generation" TruePic V image processor. Another improvement gained by the use of TruePic V was the ability to shoot usable images at ISO 6400—the highest ISO seen on any Olympus Four Thirds camera up to that point.

Movies

The E-P1 was also the first interchangeable-lens camera produced by Olympus that could shoot movies. These could be recorded in a variety of resolutions and aspect ratios including widescreen 16:9 (1280 x 720 at 30fps) and standard 4:3 (640 x 480 at 30fps) ratios. The sensor-based electronic stabilization mechanism could also be used to reduce camera shake, and the Art Mode filters could also be applied during shooting, although some of the more complex filters could reduce the video frame rate.

JARGON BUSTING: ANTI-ALIASING FILTER

A digital image is made up of discrete blocks known as pixels. Because of this, curved edges can look jagged and rough when viewed at 100% magnification. Anti-aliasing solves this problem by blurring an image slightly, so that the curved edges appear smoother. This reduces the resolution of the image slightly. The camera's anti-aliasing filter also helps combat moiré, which is an interference pattern caused when the resolution of a sensor is too coarse to resolve finely textured subjects such as cloth.

OLYMPUS PEN ≫
The inspiration for the E-P1.

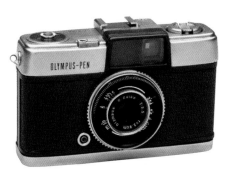

5 › Olympus E-P1 Specifications

Sensor
Resolution 12.3 megapixels
Type 4:3 aspect ratio High Speed Live MOS sensor

Image processor
TruePic V

Body
Construction Materials Metal
Lens Mount Micro Four Thirds

Image sizes
Maximum 4032 x 3024 pixels
Minimum 640 x 480 pixels

Storage media
SD Memory Card (SDHC compatible)

File formats
Still Images JPEG (Fine; Normal); Raw (12-bit); Raw+JPEG
Movie Mode AVI Motion JPEG

Focus
Type Contrast-detection system (acts as MF-assist when non high-speed contrast AF compatible lens is fitted)
Modes Single AF; Continuous AF; Manual Focus; Single AF + MF
Focus Areas 11 points (Automatic and Manual selection); 25 points (Auto selection with Face Detection set to ON); 225 points (Manual selection in Magnified View Mode)
Focus Selection Automatic; Manual
Depth of Field Preview No

Exposure
Metering Type TTL 324-zone multipattern
Metering Modes ESP light metering; Center-weighted; Spot (Approx. 2%); Highlight Spot; Shadow Spot
Exposure Modes i-Auto; Program AE (**P**); Aperture Priority (**A**); Shutter Priority (**S**); Manual (**M**)
Scene Modes Portrait; Landscape; Landscape with Portrait; Macro; Sports; Night Scene; Night Scene with portrait; Children; High key; Low key; Digital Image Stabilization; Nature Macro; Candle; Documents; Panorama; Beach and Snow; Fireworks; Sunset; e-Portrait
Art Filters Pop Art; Soft Focus; Pale & Light Color; Light Tone; Grainy Film; Pinhole
ISO Modes Auto/Manual
ISO Range 200–6400 (Auto); 100–6400 (Manual)
Exposure Compensation ±3EV in ⅓, ⅔, or 1EV steps
Exposure Bracketing 3 frames in ±⅓, ⅔, or 1EV steps
ISO Bracketing 3 frames in ±⅓, ⅔, or 1EV steps

Shutter
Type Computerized focal-plane shutter
Shutter Speed 60 seconds–1/4000 sec.; Up to 30 minutes (Bulb)

Image stabilizer

Type Sensor shift (still image);
Digital shift (movie mode)
Compensation Range Approx. 4EV steps

Viewfinder

Type Optional external VF-1 viewfinder
Magnification Approx. x 0.47
Other Information Designed for use with
17mm lens only

Drive system

Modes Single; Sequential Shooting
Max. Frame Rate 3fps (H)igh Speed;
Max. Frame Burst 10 frames (Raw);
Compression ratio and resolution
dependent (JPEG)
Self Timer 2 seconds; 12 seconds

Flash

Built-in Flash No
Modes TTL Auto; Auto; Manual; FP TTL
Auto; FP Manual Auto; Red-eye Reduction;
Slow Sync; 2nd Curtain Slow Sync; Fill-in
for exclusive flash (all with hotshoe flash)
Sync Speed 1/180 sec.; 1/4000 sec. Super
FP mode
Flash Exposure Compensation ±3EV in
⅓, ½, and 1EV steps

Movie recording

Recording Format AVI Motion JPEG
Modes HD 1280 x 720; SD 640 x 480
Frame Rate 30 fps
Maximum recording time HD 7 minutes;
SD 14 minutes
Sound Stereo PCM/16 bit (44.1kHz)

Playback monitor

Type Multiangle HyperCrystal LCD
Dimensions 3in (7.6cm)
Resolution 230,000 pixels
Coverage 100%
Languages English; German; French;
Spanish; Italian; Russian; Czech; Dutch;
Danish; Polish
Live View 100% field of view; Exposure
adjustment preview; White balance
adjustment preview; Gradation auto
preview; Face detection preview; Perfect
shot preview; Optional gridline overlay;
7x and 10x magnification; MF/S-AF & AF
frame display; AF point display; Shooting
information; Histogram

Connections

External Interfaces USB 2.0; HDMI Type
C mini connector; Optional remote cable
RM-UC1
Other Flash hotshoe

Dimensions

Size 4.7 x 2.7 x 1.4in (120.5 x 70 x 35mm)
Weight 0.7lb (335g)

Included software

Olympus Master 2; Olympus Studio 2
(trial version available as download)

Power

Rechargeable 1150 mAh Li-ion battery
pack BLS-1

» PANASONIC LUMIX DMC-GF1 September 2009

PANASONIC LUMIX DMC-GF1
With the Lumix 20mm f/1.7 G ASPH
"pancake" lens.

The design of Panasonic's first Micro Four Thirds cameras were relatively conservative, but the GF1 showed that Micro Four Thirds could be just that: micro. At the time of release the GF1 was the smallest system camera on the market with a built-in flash.

Design
Panasonic has a history of producing a popular range of compact digital cameras, and at the time of the GF1's release, the most highly regarded in the company's compact line-up was the LX3. At first glance, the GF1 was a scaled up version of the LX3, and in many ways this was no bad thing: any user who wished to upgrade to the interchangeable-lens GF1 from the LX3 (or similar Panasonic model) would have felt an immediate familiarity.

A less obvious familial relationship was with Panasonic's previous two Micro Four Thirds camera models—the G1 and GH1. It is not untrue to say that the GF1 was a very clever package of the G1's features, with some of the GH1's video capability. All of this was squeezed into a camera body that was far smaller than both.

Compared to the G1, the GF1 was 35% smaller and 26% lighter, but despite the size difference, Panasonic still managed to fit in a built-in flash that popped up using a clever, if complex, mechanism. Like the Olympus E-P1, the GF1 lacked a viewfinder, but the 3-inch/460,000 pixel LCD on the rear of the camera was more than adequate for most user's needs. Alternatively, if you were prepared to spend a bit more money, you could add the LVF1 electronic viewfinder, which plugged into an accessory port just below the flash hotshoe.

Video
The video capability of the GF1 wasn't quite on a par with the GH1, but it was still impressive for the size and price point of the camera. The resolution of the video was HD 1280 x 720 pixels using the AVCHD Lite format, and there was also the option to shoot HD Motion JPEG in a variety of different resolutions including QVGA, VGA, and WVGA.

Autofocus

In keeping with the G1 and GH1, the GF1 used a contrast-detection AF system that, with compatible lenses, almost matched the speed of conventional phase-detection system. The AF was very comprehensive on the GF1, with a choice of multiple-area AF (with up to 23 focus areas), single-area AF with a selectable focus area, Face Detection, or AF Tracking. There was also a Quick AF function that began focusing once the camera was pointed at the subject.

Exposure

The GF1 also used the intelligent ISO Control seen on previous Panasonic cameras, which increased the ISO sensitivity to raise the shutter speed and prevent motion blur if the subject moved during exposure.

Intelligent Exposure was also used by the GF1 to optimize the exposure for different elements of the image and make sure that shadows and highlights weren't underexposed and/or overexposed respectively. Further intelligence came in the form of a new backlight facility that detected when a subject was backlit and adjusted the exposure accordingly, to prevent underexposure.

PANASONIC LUMIX **«**
DMC-GF1
The 3-inch LCD almost filled the rear of the GF1.

Sensor

Resolution 12.1 megapixels (effective)
Type 4:3 aspect ratio Live MOS sensor

Body

Construction Materials Metal
Lens Mount Micro Four Thirds

Image sizes

Maximum 4000 x 3000 pixels
Minimum 1504 x 1504 pixels

Storage media

SD Memory Card (SDHC/SDXC compatible)

File formats

Still Images JPEG (Fine; Standard); Raw (12-bit); Raw+JPEG
Movie Mode AVCHD Lite; Motion JPEG

Focus

Type Contrast AF
Modes Single AF; Continuous AF; Manual Focus; Face Detection; AF Tracking
Focus Areas 1 or 23 area focusing
Focus Selection Automatic; Manual
Depth of Field Preview No

Exposure

Metering Type TTL 144 zone multipattern
Metering Modes Intelligent Multiple; Center-weighted; Spot
Exposure Modes Program AE (**P**); Aperture Priority (**A**); Shutter Priority (**S**); Manual (**M**)

Scene Modes (still images) Portrait; Soft Skin; Scenery; Architecture; Sports; Peripheral Defocus; Flower; Food; Objects; Night Portrait; Night Scenery; Illuminations; Baby 1 & 2; Pet; Party; Sunset
Scene Modes (movie mode) Portrait; Soft Skin; Scenery; Architecture; Sports; Flower; Food; Objects; Low-light; Party; Sunset
ISO Modes Auto/Manual; Intelligent ISO
ISO Range 100–3200
Exposure Compensation ±3EV in ⅓EV steps
Exposure Bracketing 3, 5, or 7 frames, ±2EV in ⅓ or ⅔EV steps

Shutter

Type Computerized focal-plane shutter
Shutter Speed 60 seconds–1/4000 sec.; Up to 4 minutes (Bulb)

Viewfinder

Type Optional externally fitted DMW-LVF1 electronic viewfinder
Coverage 100%
Resolution Approx. 202,000 pixels
Magnification x1.04
Eyepoint Approx. 17.5mm
Diopter Adjustment -4.0 to +4

Drive system

Modes Single; Continuous Shooting
Max. Frame Rate 3fps (H)igh Speed; 2fps (L)ow Speed

Max. Frame Burst 7 frames (Raw);
Compression ratio and resolution
dependent (JPEG)
Self Timer 2 seconds; 10 seconds ;
10 seconds (3 images)

Flash
Built-in Flash Yes
Guide Number 20ft/6m @ ISO 100
Modes Auto; Auto Red-eye Reduction;
Forced On; Forced On Red-eye Reduction
Slow Sync; Slow Sync Red-eye Reduction;
Forced Off
Sync Speed 1/160 sec.

Movie recording
Recording Format AVCHD Lite; Motion
JPEG
AVHCD Modes Lite HD 1280 x 720 60p/50p
(three quality settings SH, H, L)
Motion JPEG Modes QVGA 320 x 240; VGA
640 x 480; WVGA 848 x 480; HD 1280 x 720
Frame Rate 30fps (NTSC); 25fps (PAL)
Maximum Recording Time Up to 210
minutes using AVHCD at SH quality

Playback monitor
Type Low temperature Polychrystalline
TFT LCD
Dimensions 3in (7.6cm)
Resolution 460,000 pixels
Coverage 100%
Languages English; Japanese; German;
French; Italian; Spanish

Live View Optional guide lines; Real-time
histogram

Connections
External Interfaces USB 2.0; Video out;
HDMI Type C mini connector; 2.5mm
Remote Control Socket
Other Flash hotshoe

Dimensions
Size 4.69 x 2.8 x 1.43in (119 x 71 x 36.3mm)
Weight 15.8oz (448g)

Included software
PHOTOfunSTUDIO 4.0 HD Edition;
SILKYPIX Developer Studio 3.0 SE

Power
Rechargeable 1250 mAh Li-ion battery

5 » IMAGE STABILIZATION

If your camera moves during an exposure it is likely that the resulting image will be marred by "camera shake." This results in a directional softening of the image, the softening matching the direction of the movement during the exposure. If you are handholding your camera, then the longer the shutter speed, the greater the risk of camera shake.

The problem is more acute with longer focal lengths, as any movement of the lens during the exposure is magnified. This means that it is important to use a faster shutter speed with a long focal length.

Fortunately, camera manufacturers understand this, so if you are using your camera's Program (**P**) or Automatic mode, it will endeavor to use a faster shutter speed when it registers that a lens with a long focal length is attached.

The most obvious solution is to use a tripod, but tripods are bulky and are not really suited to spontaneous photography. For that reason Image Stabilization is definitely beneficial, especially for handheld photography. An Image Stabilization (IS) system compensates for any movement of the camera during

LUMIX G VARIO 45–200MM ⌄
A wide-ranging zoom, and just one of Panasonic's lenses with Image Stabilization.

Notes:
Some Olympus cameras have a Digital Image Stabilization (DIS) mode. This is not true IS, but allows the camera to increase the ISO to maintain fast shutter speeds when light levels drop. While this helps to avoid camera shake, increasing the ISO will lead to an inevitable drop in image quality.

Both lens-based and sensor-based stabilization should be deactivated when your camera is mounted firmly on a tripod, otherwise it can generate a small amount of blur.

Do not use a MEGA O.I.S. lens with its IS enabled on a camera that has sensor-based IS switched on.

the exposure and, although it varies to a certain extent on the steadiness of the photographer, it can mean that shutter speeds up to five stops longer than would usually be considered "safe" can be used without introducing camera shake.

Image Stabilization has been realized in two different ways in the Four Thirds and Micro Four Thirds standard. The first is lens-based IS, which uses a system of tiny gyros in the lens to detect movement, and then shifts various lens elements to compensate and cancel it out.

The big advantage with lens-based stabilization is that the effect is apparent in an optical viewfinder. This is particularly useful if your camera does not have Live View. There are currently three Four Thirds and four Micro Four Thirds IS lenses produced by Leica/Panasonic (referred to as MEGA O.I.S.).

The second method of avoiding camera shake is sensor-shift IS, where the sensor itself is shifted to compensate for camera movement. Unlike lens-based IS this compensation is not visible through an optical viewfinder, but it is visible in Live View. Sensor-shift IS allows you to use any lens and benefit from the stabilization effect, without needing to buy (often more expensive) IS-enabled lenses. Another advantage over lens-based systems is that shifting a sensor requires less power than shifting the glass in a lens, so it potentially means that your camera battery will be drained less quickly.

STEAM TRAIN »
Image Stabilization is particularly useful with long lenses when the light levels are low; a tripod might be a hindrance and the slow shutter speed required could result in camera shake.

5 » OLYMPUS E-P2 November 2009

OLYMPUS E-P2 ⌃
With optional VF-2 viewfinder.

The Olympus E-P2 was a subtle upgrade to the E-P1, and its launch—just six months after its predecessor—meant one of two things: either Olympus had got much of the camera right in the first instance, or a few key refinements that couldn't be fixed via the firmware were needed.

Perhaps the most important addition to the E-P2 was an accessory port above the LCD on the back of the camera. The port principally allowed the addition of the VF-2 electronic viewfinder, which was useful for lighting conditions when the LCD screen was difficult to see, or for photographers who didn't want to use the LCD with the camera held at arms length. The accessory port could also be used for other devices, such as the SEMA-1 microphone adapter set to improve sound quality when shooting movies.

E-P2 versus E-P1

Improved focusing speed Olympus increased the sensitivity of the E-P2's contrast-detection focusing system. The AF system was improved retrospectively on the E-P1 with a firmware update.

Art Filters Cross Process and Diorama were added to the six Art Filters found on the E-P1.

iEnhance Selectively enhances the color of images by increasing the saturation, particularly with blue skies.

JARGON BUSTING: FIRMWARE

A digital camera is a masterpiece of electronics, and keeping control of the electronic systems is software known as firmware. Occasionally, manufacturers release updates to the camera firmware to either fix known issues with a camera, or to add extra functionality.

CROSS PROCESS »

The Cross Process Art Filter adds a unique feel to an image, and while it may not be to everyone's taste, it is fun to use.

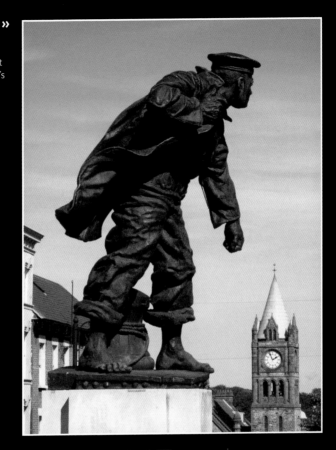

Settings
> Focal length: 30mm
> Aperture: f/6.3
> Shutter speed: 1/320 sec.
> ISO 80

5 » ACCESSORIES

There are many accessories available for the Four Thirds and Micro Four Thirds cameras. Although there isn't room in this book to mention all of the different items of equipment produced, the following should give you an idea of how the latest cameras in the Four Thirds and Micro Four Thirds range can be expanded.

Power

Without power, a digital camera is just an expensive paperweight, so it makes sense to keep a fully charged spare battery with you on your day's shooting. Alternatively, if most of your photography is done indoors, you can use an AC power pack if one is available for your camera. These are particularly useful when it is important that power is not interrupted, such as when the camera is copying data to a PC.

Ergonomics

There are optional battery grips for several of the Olympus Four Thirds cameras. As the name suggests, extra batteries can be used in the grip to keep the camera powered for longer. They are also useful for keeping the camera steady when holding it vertically and include an extra shutter button and control dial.

Viewfinders

Micro Four Thirds cameras without a viewfinder rely on the LCD for composing images, reviewing your pictures, and setting the various camera parameters. Some Micro Four Thirds cameras accept a supplementary electronic viewfinder (EVF) that operates in a similar fashion to a traditional digital SLR "eye-level" viewfinder.

Panasonic DMW-BLB13 Battery

Olympus HLD-5 Power Grip

Panasonic DMW-LVF1 Viewfinder

Protection

One of the first items of equipment that most people buy for their new camera is a bag to put it in. What bag you choose will depend on how far and how quickly you intend to expand you camera equipment: buy a bag that is too small and it will quickly be outgrown, but if it is too large it will be cumbersome for no good reason.

It is also worth considering carefully the straps. A simple camera bag with one strap will be the least expensive option, but single-strap bags place all of the weight on one shoulder and can be uncomfortable when used for over a period of time. Bags with two shoulder straps are more expensive, but tend to be bigger and therefore more expandable, as well as being more comfortable to carry.

Movies

Cameras that can shoot movies have built-in microphones to record sound, but these will often pick up any noise that the camera makes during recording, as well as the noise of any wind as it blows across the microphone aperture.

Both of these problems can be solved by plugging an external microphone into your camera. This will allow you to position the mic away from the camera, and closer to your subject, for improved sound quality. If the microphone has a foam cover, this will help to reduce the effect of wind noise, as well as protecting the microphone head itself.

Panasonic DMW-PGS19 Camera Bag

Panasonic DMW-MS1 Microphone

Olympus E-P2 with SEMA-1 Microphone

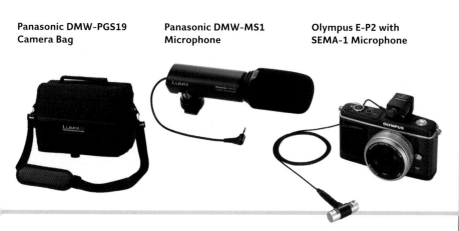

» OLYMPUS E-PL1 February 2010

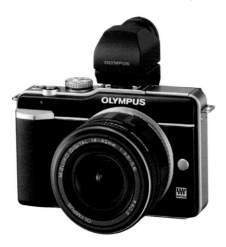

OLYMPUS E-PL1
Unlike the E-P1, the E-PL1 had an accessory port that allowed it to be used with the optional VF-2 viewfinder.

The Olympus E-P1 may have looked more like a compact digital camera than a digital SLR, but it was still very much a part of a camera system. This meant that it was unavoidably more expensive than the compact cameras it could superficially be compared to. However, by stripping the E-P1 down, the price could be brought down also, and hence the Olympus E-PL1 was launched.

The affordable PEN

To make a less expensive digital PEN was a laudable ambition on Olympus's part, but this inevitably meant there were some features lacking on the E-PL1 compared to its sibling. The most obvious difference was a greater reliance on buttons rather than dials. This meant that the handling suffered slightly, as more options had to be set using menu screens. The cost savings also applied to the body construction, which included more plastic than its predecessor, and the Zuiko 14–42mm kit lens was also given a less expensive plastic mount.

Given the cost-cutting nature of the exercise, it was rather surprising that the E-PL1 still managed to eclipse the E-P1 in a number of ways, the biggest of which was the addition of a flash unit that folded neatly inside the camera body. With a guide number of 23ft (7m) at ISO 100 it wasn't particularly powerful, but it was still eminently usable for fill-in flash purposes.

Automatic for the people

Olympus's aim at tempting potential buyers away from a compact camera was also apparent in the number of automatic modes on the E-PL1. There were 19 scene-select modes, ranging from portrait through to a mode to help you capture firework displays successfully, and, if you didn't even want to go to the trouble

of setting a scene mode, there was Intelligent Auto (iAuto) that would attempt to identify the type of scene you were trying to photograph and set an appropriate exposure. In the digital age, it seemed as though the Olympus E-PL1 came close to fulfilling the old Kodak slogan: "You press the button, and we'll do the rest."

The E-PL1 also had a panorama mode that could stitch three images together to produce a wide image, with the supplied software allowing you to increase this to up to ten frames. More care was needed when lining the images up at the point of shooting though, as a re-shoot was harder once you were back at your computer!

Movies

The ability to shoot HD movies was almost an obligatory feature on a camera when the E-PL1 was released, and Olympus did not disappoint. The E-PL1 was able to shoot HD-quality movies at a resolution of 1280 x 720 pixels, and SD at 640 x 480 pixels, both at 30fps. Output was via HDMI, with the HDTV's remote control able to control playback from the camera.

E-PL1S

In November 2010, Olympus released the E-PL1s, an updated version of the E-PL1 that was initially available only in Japan. Added to the original specification was an increase in the ISO range to ISO 6400, an updated Lithium-ion battery, and a wider choice of body colors.

OLYMPUS E-PL1 «
The rear panel was simplified in comparison to the E-P1.

Sensor

Resolution 12.3 megapixels (effective)
Type 4:3 aspect ratio High Speed Live
MOS sensor

Image processor

TruePic V

Body

Construction Materials Aluminum/Plastic
Lens Mount Micro Four Thirds

Image sizes

Maximum 4032 x 3024 pixels
Minimum 1024 x 768 pixels

Storage media

SD Memory Card (SDHC compatible)

File formats

Still Images JPEG (Fine; Normal); Raw
(12-bit); Raw+JPEG
Movie Mode AVI Motion JPEG

Focus

Type Contrast-detection system (acts as
MF assist when non high-speed contrast
AF compatible lens is fitted)
Modes Single AF; Continuous AF; Manual
Focus; Single AF + MF; AF Tracking
Focus Areas 11 points (Automatic and
Manual selection); 225 points (Manual
selection in Magnified View Mode)
Focus Selection Automatic; Manual
Depth of Field Preview No

Exposure

Metering Type TTL 324 zone multipattern
Metering Modes ESP light metering;
Center-weighted; Spot (Approx. 2%);
Highlight Spot; Shadow Spot
Exposure Modes i-Auto; Program (**P**);
Aperture Priority (**A**); Shutter Priority (**S**);
Manual (**M**)
Scene Modes Portrait; Landscape;
Landscape with Portrait; Macro; Sports;
Night Scene; Night Scene with Portrait;
Children; High key; Low key; Digital Image
Stabilization; Nature Macro; Candle;
Documents; Panorama; Beach and Snow;
Fireworks; Sunset; e-Portrait
Art Filters Pop Art; Soft Focus; Grainy Film;
Pinhole; Diorama; Gentle Sepia
ISO Modes Auto/Manual
ISO Range 200–3200 (Auto); 100–3200
in ⅓ or 1EV steps (Manual)
Exposure Compensation ±3EV in ⅓, ⅔,
or 1EV steps
Exposure Bracketing 3 frames in ±⅓, ⅔,
or 1EV steps
ISO Bracketing 3 frames in ±⅓, ⅔, or
1EV steps
Other Multi-Exposure 2 frames (shooting);
3 frames (editing)

Shutter

Type Computerized focal-plane shutter
Shutter Speed 60 seconds–1/2000;
Up to 30 minutes (Bulb)

Image stabilizer

Type Sensor shift (still image);
Digital Image (movies)
Modes Two-dimensional; Vertical Only;
Horizontal Only
Compensation Range Approx. 3EV steps

Viewfinder

Type Optional externally fitted optical
VF-1 or electronic VF-2 viewfinder
Magnification x0.47 (VF-1); x1.15 (VF-2)
VF-2 Resolution 1,440,000 pixels
Other Information VF-1 designed for use
with 17mm lens only

Drive system

Modes Single; Sequential Shooting
Max. Frame Rate 3fps
Max. Frame Burst 10 frames (Raw);
Compression ratio and resolution
dependent (JPEG)
Self Timer 2 seconds; 12 seconds

Flash

Built-in Flash Yes
Guide Number 23ft/7m @ ISO 100
Flash Modes FP TTL Auto; FP Manual;
TTL-Auto; AUTO; Manual (Full; 1/4, 1/16;
1/64), Red-eye reduction; Slow sync, Slow
sync 2nd curtain, Slow sync with red-eye
reduction; Fill-in
Sync Speed 1/160 sec.; 1/2000 sec. Super
FP mode
Flash Exposure Compensation ±3EV in 1/3,
1/2, and 1EV steps (external flashgun)

Movie recording

Recording Format AVI Motion JPEG
Modes HD (1280 x 720 pixels);
SD (640 x 480 pixels)
Frame Rate 30 fps
Maximum Recording Time HD 7 minutes;
SD 14 minutes
Sound Stereo PCM/16 bit (44.1kHz)

Playback monitor

Type Multi-angle HyperCrystal LCD
Dimensions 2.7in (6.7cm)
Resolution 230,000 pixels
Coverage 100%
Languages English; German; French;
Spanish; Italian; Russian; Czech; Dutch;
Danish; Polish; Other European and Asian
languages also available

Connections

External Interfaces Combined USB 2.0 and
Video Output; HDMI Type C connector
Other Flash hotshoe

Dimensions

Size 4.53 x 2.83 x 1.65in (115 x 72 x 42mm)
Weight 0.65lb (296g)

Included software

Olympus Master 2

Power

Rechargeable 1150 mAh Li-ion battery
pack BLS-1 battery

5 » PANASONIC LUMIX DMC-G2 March 2010

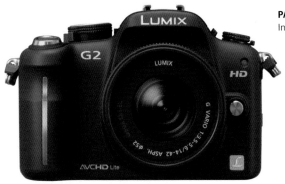

The Panasonic G2 was an evolutionary development of the G1 and at first glance there seemed little difference between the two cameras, other than the addition of a few buttons. Delving deeper, however, soon revealed that the G2 was a far more serious photographic tool than the G1.

Touch sensitive

The most intriguing aspect of the G2 was its new 3-inch LCD screen. Although the size and 460,000-pixel resolution were not revolutionary, the fact that it was touch-sensitive was. Menu settings and other camera controls could be altered with the touch of a finger (or supplied stylus), and it was possible to select where the camera focused simply by touching the screen.

This seemed to be a control method aimed at photographers who were more familiar with compact cameras, although using the touch screen worked best when the G2 was mounted on a tripod so that the composition wasn't disturbed when pressing the LCD.

Focusing

The G2 had the same contrast-detection of the G1, but with a few refinements: while the G1's autofocus was not compatible with all Four Thirds lenses attached using an adapter, the G2's AF system was. A basic distance scale was also shown as a visual aid to focusing manually.

G2 versus G1

Venus Engine HD II "Intelligent Resolution" incorporated into the G2 for greater image resolution.

Auto ISO More sensitive than the G1 and increases sooner to maintain faster shutter speeds and avoid the risk of camera shake.

ISO Expanded to ISO 6400.

Live View Remains on during continuous shooting, but with a reduced burst rate (Medium and Low only).

Body Minor button changes, including the addition of dedicated iAuto and movie buttons. Control dial moved from the front of the hand grip to the rear of the camera; SD memory card slot moved to battery compartment; focus mode dial added.

Movie mode Maximum movie size increased to HD 1280 x 720 60p/50p; three levels of compression (SH, H, L) using AVHCD Lite; built-in mono microphone with connector for external stereo mic.

TOUCH SCREEN »
Focusing the G2.

Sensor
Resolution 12.1 megapixels (effective)
Type 4:3 aspect ratio Live MOS sensor

Image processor
Venus Engine HD II

Body
Construction Materials Plastic
Lens Mount Micro Four Thirds

Image sizes
Maximum 4000 x 3000 pixels
Minimum 1504 x 1504 pixels

Storage media
SD Memory Card
(SDHC/SDXC compatible)

File formats
Still Images JPEG (Fine; Normal); Raw
(12-bit); Raw+JPEG
Movie Mode AVCHD Lite; QuickTime
Motion JPEG

Focus
Type Contrast AF
Modes Single AF; Continuous AF; Manual
Focus; Face Detection; AF Tracking
Focus Areas 1 or 23 area focusing
Focus Selection Automatic; Manual,
Touch AF
Depth of Field Preview No

Exposure
Metering Type TTL 144 zone multipattern
Metering Modes Intelligent Multiple;
Center-weighted; Spot

Exposure Modes Programmed AE (**P**);
Aperture Priority (**A**); Shutter Priority (**S**);
Manual (**M**)
Scene Modes (still images) Portrait
(Normal, Soft Skin, Outdoor, Indoor,
and Creative); Scenery (Normal, Nature,
Architecture, and Creative); Sports
(Normal, Outdoor, Indoor, and Creative);
Close-up (Flower, Food, Objects, and
Creative); Night Portrait (Night Portrait,
Night, Scenery, Illuminations, and
Creative); SCN (Sunset, Party, Baby 1 & 2,
Pet, and Peripheral Defocus)
Scene Modes (movie mode) Portrait
(Normal, Soft Skin, Outdoor, Indoor,
and Creative); Scenery (Normal, Nature,
Architecture, and Creative); Sports
(Normal, Outdoor, Indoor, and Creative);
Close-up (Flower, Food, Objects, and
Creative); Low Light; SCN (Sunset, Part,
and Portrait)
ISO Modes Auto/Manual; Intelligent ISO
ISO Range 100–6400
Exposure Compensation ±3EV in ⅓EV steps
Exposure Bracketing 3, 5, or 7 frames, ±2EV
in ⅓ or ⅔EV steps

Shutter
Type Electronic focal-plane shutter
Shutter Speed 60 seconds–1/4000 sec.;
Up to 4 minutes (Bulb)

Viewfinder
Type Electronic Live View Finder
Coverage 100%
Resolution Approx. 1,440,000 pixels

Magnification x1.4
Eyepoint Approx. 17.5mm
Diopter Adjustment -4.0 to +4.0
Other information Automatic eye sensor

Drive system
Modes Single; Continuous Shooting
Max. Frame Rate 3.2fps (H)igh Speed;
2.6fps (M)edium with Live View;
2fps (L)ow with Live View
Max. Frame Burst 7 frames (Raw);
Compression ratio and resolution
dependent (JPEG)
Self Timer 2 seconds; 10 seconds;
10 second (3 images)

Flash
Built-in Flash Yes
Guide Number 36ft/11m @ ISO 100
Modes Auto; Auto red-eye reduction;
Forced on; Forced on red-eye reduction
slow sync; Slow sync red-eye reduction;
Off; 1st curtain sync, 2nd curtain sync
Sync Speed 1/160 sec.
Flash Exposure Compensation ±2EV in
⅓EV steps

Movie recording
Recording Format AVCHD Lite; QuickTime
Motion JPEG
AVHCD Lite Mode HD 1280 x 720 60p/50p
(three levels of compression SH, H, L)
Motion JPEG Modes QVGA 320 x 240; VGA
640 x 480; WVGA 848 x 480; HD 1280 x 720
Frame Rate 30fps (NTSC); 25fps (PAL)
Maximum Recording Time Up to 180
minutes using AVCHD at SH quality

Playback monitor
Type Multiangle HyperCrystal LCD with
touch panel
Dimensions 3in (7.6cm)
Resolution 460,000 pixels
Coverage 100%
Languages English; Japanese; German;
French; Italian; Spanish
Live View Three optional guidelines; Real-
time histogram

Connections
External Interfaces USB 2.0; HDMI Type C
mini connector; Combined stereo mini
microphone jack and remote release
socket
Other Flash hotshoe

Dimensions
Size 4.88 x 3.29 x 2.9in (124 x 83.6 x 74mm)
Weight 1.37lb (593g)

Included software
PHOTOfunSTUDIO 5.0 HD Edition;
SILKYPIX Developer Studio 3.1 SE;
QuickTime

Power
Rechargeable 1250 mAh Li-ion battery

5 » SHOOTING MOVIES

The addition of movie modes to cameras has required the learning of a whole new set of terms. The following describes some of the terms and features you will come across when shooting movies:

Aspect ratio

Describes the proportions of a movie (and still image) as a ratio of its width to the height, without the need to specify a particular measurement. HDTVs have screens with an aspect ratio of 16:9 (sometimes represented as 1.77:1), so if the width of a screen is 32 inches, the height would be 18 inches, while a 64-inch wide screen would be 36 inches high, and so on.

Compression

Digital video is essentially a long stream of individual images that appear as a continuous moving picture when played back at a fast enough speed rate. If each of these images was stored as an individual file, then just a few minutes of video footage would require huge amounts of storage space on the memory card.

The reason that digital video takes up comparatively little room is because the data is compressed: in exchange for a reduction in quality, video files can be reduced considerably. MPEG-2 is the compression standard used for DVD, while the slightly more advanced MPEG-4 is used by Panasonic for its AVHCD format.

MOVIE EDITING «
There is a number of third-party movie editors including *Final Cut Express* for Mac (shown here) and *Adobe Premiere Elements* for Windows.

File format

There are several different standards for video file formats. Panasonic typically use AVHCD format, developed in conjunction with Sony, but Olympus has used both Apple QuickTime (saved as .MOV) and Microsoft AVI (.AVI) files for its video-enabled cameras.

HDMI

A High Definition Multimedia Interface is a connection standard to allow the transmission of audio and video along a cable between two devices. Most HDTV sets will have at least one HDMI port, and all Four Thirds and Micro Four Thirds cameras released since 2009 have an HDMI port. Note that HDTVs most often have a Type A plug, whereas cameras use the smaller Type C plug. However, Type A to Type C cables are common and can be bought from most good electronics stores.

HDTV

High Definition Television will eventually replace analog television as a means of broadcasting video. HDTVs have a 16:9 aspect ratio with a resolution of either 1280 x 720, 1366 x 768, or 1920 x 1080 pixels.

HDTVs vary in the frame rate that video is replayed at, split between 50hz systems (mainly Europe) that typically have frame rates of 25 or 50fps and 60hz systems

HIGH-DEFINITION MULTIMEDIA INTERFACE

(chiefly in North America and Japan) that support 24, 30, or 60fps.

A final factor is whether the display is progressive or interlaced. Progressive systems draw each line of pixels in a frame down the screen in sequence, before returning to the top for the next frame. Interlace systems draw all the odd lines first, before drawing all the even lines.

All of the factors above are shortened when an HDTV's capabilities are described. So a 1080p50 set would: have a resolution of 1920 x 1080 pixels; use progressive scanning; have a frame rate of 50fps.

USB

The Universal Serial Bus is a connection standard found on most cameras, computers, and some HDTVs. As with HDMI, there are several USB connectors: computers use the Type A connector and cameras use the smaller Mini B type. Although live video can be transmitted down a USB connection, USB is more used to copy digital data to another device, either to back the data up or, in the case of video, to edit the video file.

5 » PANASONIC LUMIX DMC-G10 March 2010

PANASONIC LUMIX DMC-G10 «
With G Vario 14–42mm f/3.5–5.6
Mega O.I.S. kit lens.

Released in the same month as the G2, Panasonic's G10 did without some of the G2's more advanced features to reduce the cost and make it appeal to novice users who might otherwise contemplate a digital compact camera.

The biggest loss was the articulated touch-screen LCD and high-resolution EVF, which combined to make the G2 such a pleasure to use. That did not mean that the G10 was a lesser camera, though— the image quality from the 12.1 sensor remained the same, as did most of the essential photographic controls.

G10 versus G2

Weight Without the articulated LCD, the G10 is approximately 1.23oz (32g) lighter.

EVF/LCD Switch Automatic switching removed from the G10.

Dedicated movie recording button Button removed: the G10's movie mode is selected using the exposure mode dial.

Movie recording format AVHCD format is replaced by Motion JPEG on the G10.

External microphone Without a stereo microphone jack, all sound is recorded using the G10's internal microphone.

TEXTURE »
With 12.1 megapixels, the G10 has no problem resolving fine details such as sand and rock texture.

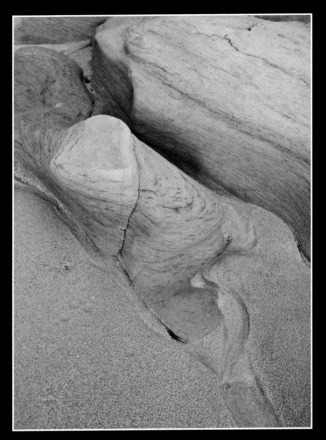

Settings
> *Focal length: 40mm*
> *Aperture: f/14*
> *Shutter speed: 1/6 sec.*
> *ISO 100*

Sensor

Resolution 12.1 megapixels (effective)
Type 4:3 aspect ratio Live MOS sensor

Image processor

Venus Engine HD II

Body

Construction Materials Plastic
Lens Mount Micro Four Thirds

Image sizes

Maximum 4000 x 3000 pixels
Minimum 1504 x 1504 pixels

Storage media

SD Memory Card (SDHC/SDXC
compatible)

File formats

Still Images JPEG (Fine; Normal);
12-bit Raw; Raw+JPEG
Movie Mode Motion JPEG

Focus

Type Contrast AF
Modes Single AF; Continuous AF; Manual
Focus; Face Detection; AF Tracking
Focus Areas 1 or 23 area focusing
Focus Selection Automatic; Manual
Depth of Field Preview No

Exposure

Metering Type TTL 144 zone multipattern
Metering Modes Intelligent Multiple;
Center-weighted; Spot
Exposure Modes Program (**P**); Aperture
Priority (**A**); Shutter Priority (**S**); Manual (**M**)
Scene Modes (still images) Portrait
(Normal, Soft Skin, Outdoor, Indoor,
and Creative); Scenery (Normal, Nature,
Architecture, and Creative); Sports
(Normal, Outdoor, Indoor, and Creative);
Close-up (Flower, Food, Objects, and
Creative); Night Portrait (Night Portrait,
Night, Scenery, Illuminations, and
Creative); SCN (Sunset, Party, Baby 1 & 2,
Pet, and Peripheral Defocus)
ISO Modes Auto/Manual Intelligent ISO
ISO Range 100–6400
Exposure Compensation ±3EV in ⅓EV steps
Exposure Bracketing 3, 5, or 7 frames, ±2EV
in ⅓ or ⅔EV steps

Shutter

Type Electronic focal-plane shutter
Shutter Speed 60 seconds–1/4000 sec.;
Up to 4 minutes (Bulb)

Viewfinder

Type Electronic Live View Finder
Coverage 100%
Resolution Approx. 202,000 pixels
Magnification x1.04
Eyepoint Approx. 17.5mm
Diopter Adjustment -4.0 to +4.0

Drive system
Modes Single; Continuous Shooting
Max. Frame Rate 3.2fps (H)igh Speed;
2.6fps (M)edium with Live View;
2fps (L)ow with Live View
Max. Frame Burst 7 frames (Raw);
Compression ratio and resolution
dependent (JPEG)
Self Timer 2 seconds; 10 seconds;
10 seconds (3 images)

Flash
Built-in Flash Yes
Guide Number 36ft/11m @ ISO 100
Flash Modes Auto; Auto red-eye
reduction; Forced on; Forced off; Forced
on red-eye reduction slow sync; Slow sync
red-eye reduction; 1st curtain sync, 2nd
curtain sync
Sync Speed 1/160 sec.
Flash Exposure Compensation ±2EV in
⅓EV steps

Movie recording
Recording Format Motion JPEG
Motion JPEG Modes QVGA 320 x 240; VGA
640 x 480; WVGA 848 x 480; HD 1280 x 720
Frame Rate 30fps

Playback monitor
Type Polychrystalline TFT LCD
Dimensions 3in (7.6cm)
Resolution 460,000 pixels
Coverage 100%

Languages English; German; French;
Italian; Spanish; Polish; Czech; Hungarian;
Russian; Chinese (Traditional); Chinese
(Simplified); Dutch; Thai; Korean; Turkish;
Portuguese; Arabic; Persian; Japanese;
Swedish; Danish; Finnish; Greek
Live View Digital Zoom (2x; 4x); Three
optional guidelines; Real-time histogram

Connections
External Interfaces USB 2.0; HDMI Type
C mini connector
Other Flash hotshoe

Dimensions
Size 4.88 x 3.29 x 2.9in (124 x 83.6 x 74mm)
Weight 19.68oz (558g)

Included software
PHOTOfunSTUDIO 5.0; SILKYPIX
Developer Studio 3.1 SE; QuickTime

Power
Rechargeable 1250 mAh Li-ion

the white paint scheme of the church tower and the ornately decorated building façade in the foreground that caught my attention. By using a relatively long focal length (75mm, giving the equivalent angle of view of a 150mm lens on a "full frame" camera) I was able to isolate both buildings. Because depth of field extends further back than forward from the focus point I was careful to focus on the foreground building, rather than the church tower.

REFLECTIONS

Framing a composition that uses symmetry immediately creates an esthetically pleasing image. A reflection in still water is probably the symmetry we are most familiar with. However, water is not a perfect mirror and therefore the reflection is often much darker than the subject. To help balance the exposure in this photograph I used a 2-stop neutral density graduated filter over the top half of the scene. I could have used a stronger filter so that the two halves of the picture matched, but this would have looked unnatural. We expect, even subconsciously, that reflections will be darker than the scene they reflect.

Settings
> *Focal length: 20mm*
> *Aperture: f/13*
> *Shutter speed: 25 sec.*
> *ISO 100*

Chapter 6
THE VIDEO AGE

6 THE VIDEO AGE

The ability to shoot movies is now a standard feature for the latest Four Thirds SLR cameras and Micro Four Thirds models, regardless of whether they are made by Olympus or Panasonic.

» OLYMPUS E-5 October 2010

OLYMPUS E-5 ⌃
With optional HLD-5 battery holder.

At the time of writing, the Olympus E-5 is the latest Four Thirds SLR camera to be released and the successor to 2007's E-3. As such, it is the company's flagship model, aimed squarely at the most demanding professional users.

Tough
As befits a camera targeting the professional market, the E-5 is built for heavy use, so at its core is a strong, yet lightweight, magnesium alloy chassis. In keeping with its predecessors, the control points are all sealed to stop the ingress of dust and moisture, and it also features the sensor-based dust removal system seen on all previous Olympus digital SLRs.

Imaging
The E-5 uses a 12.3-megapixel, stabilized, High-Speed Live MOS sensor, of the type used in the E-30 and PEN cameras. This is backed by a TruePic V+ image processor (a refinement of the technology used in Olympus's previous Four Thirds cameras), which now incorporates Fine-Detail Processing. This allows greater apparent resolution to be extracted from what was, in 2010, a relatively low resolution, 12.3-megapixel sensor.

The E-5 also offers the Art Filters found in the PEN camera series, including the new Dramatic Tone. According to Olympus, this filter "Represents real space in a more imaginary way by applying unrealistic tones of light and darkness based on local changes in contrast."

OLYMPUS E-5 »
The hinged LCD is a useful compositional tool when shooting from low down or above head height.

Movies

The ability to shoot movies is a first on Olympus's pro-spec E-x range of Four Thirds cameras, but the E-5 allows movies to be recorded in HD using either a 16:9 aspect ratio at a resolution of 1280 x 720 pixels, or standard 4:3 at 640 x 480 pixels (both at 30fps). The built-in electronic image stabilization also works with movies, giving the E-5 a pseudo "steadicam" facility.

The audio is recorded in linear PCM using the built-in microphone, although there is a stereo jack for external mics. The built-in microphone can be used to record audio memos when shooting still images, and whether you use an internal or external mic, the audio signal is uncompressed for maximum sound quality.

Autofocus

The E-5 has an 11-point AF sensor, with each point consisting of a crossed array for improved focusing accuracy. This helps the camera detect movement in the horizontal and vertical directions, with "fuzzy logic" employed to determine how a subject is moving so that focus is maintained.

LCD and viewfinder

The LCD used by the E-5 is a significant improvement over the unit found in the E-3: it is a larger, 3-inch unit with a resolution of approximately 920,000 pixels. Unlike the E-3, the LCD is also hinged, allowing free movement both horizontally and vertically.

When the E-5 is used in Live View mode, the LCD can display a level gauge for accurate alignment of the camera, which is particularly useful for architecture photographers who need to make sure that their camera is parallel to the subject. The 100% viewfinder can also display a gauge, although this is only sensitive to horizontal movement.

Sensor
Resolution 12.3 megapixels (effective)
Type 4:3 aspect ratio High Speed Live
MOS sensor

Image processor
TruePic V+

Body
Construction Materials Magnesium Alloy
Lens Mount Four Thirds

Image sizes
Maximum 4032 x 3024 pixels
Minimum 640 x 480 pixels

Storage media
CompactFlash (Types I & II); Micro Drive;
SD (SDHX/SDXC compatible)

File formats
Still Images JPEG (SHQ/HQ/SQ); Raw
(12-bit); Raw+JPEG
Movie Mode AVI Motion JPEG

Focus
Type TTL Phase Difference Detection
Modes Single AF; Continuous AF; Manual
Focus; Single AF + MF; Continuous AF +
MF; AF Tracking (in Continuous AF mode)
Focus Areas 11 points (fully biaxial)
Focus Selection Automatic; Manual
Detection Range EV-2-19 (at ISO 100)
Depth of Field Preview Yes

Exposure
Metering Type TTL with 49-zone
multipattern system
Detection Range 1–20EV

Metering Modes Digital ESP; Center-
weighted; Spot (Approx. 2%); Highlight
Spot; Shadow Spot
Exposure Modes Program AE (**P**); Aperture
Priority (**A**); Shutter Priority (**S**); Manual (**M**)
Art Filters Pop Art; Soft Focus; Pale & Light
Color; Light Tone; Grainy Film; Pinhole;
Diorama; Gentle Sepia; Cross Process;
Dramatic Tone
ISO Modes Auto/Manual
ISO Range 200–6400 (Auto); 100–6400 in ⅓
or 1EV steps (Manual)
Exposure Compensation ±5EV in ⅓, ⅔,
or 1EV steps
Exposure Bracketing 2, , 3, or 5 frames in ±⅓,
⅔, or 1EV steps; 7 frames in ±⅓ or ⅔EV steps
ISO Bracketing 3 frames in ±⅓, ⅔, or
1EV steps

Shutter
Type Computerized focal-plane shutter
Shutter Speed 60 seconds–1/8000 sec.;
Up to 30 minutes (Bulb)

Image stabilizer
Type Sensor shift (still image);
Digital shift (movie mode)
Compensation Range Approx. 5EV steps

Viewfinder
Type Eye-level TTL optical pentaprism
Coverage Approx. 100%
Magnification Approx. x1.15 (with 50mm
lens set to infinity)
Eyepoint Approx. 20mm
Diopter Adjustment -3.0 to +1.0

Drive system

Modes Single; Sequential Shooting
Max. Frame Rate 5fps (H)igh Speed;
1–4fps (L)ow Speed
Max. Frame Burst 16 frames (Raw);
Up to card capacity (JPEG HQ)
Self Timer 2 seconds; 12 seconds

Movie recording

Recording Format AVI Motion JPEG
Modes HD 1280 x 720; SD 640 x 480
Frame Rate 30 fps
Maximum Recording Time HD 7 minutes;
SD 14 minutes
Sound Stereo PCM/16 bit (44.1kHz)

Flash

Built-in Flash Yes
Guide Number 42ft/13m @ ISO 100
Modes Auto; Manual; Red-eye reduction;
Slow sync; Slow sync with red-eye
reduction; 2nd curtain slow sync; Fill-in;
Bracketing (3 frames in ⅓, ½, or 1EV steps)
Sync Speed 1/250 sec.; 1/8000 sec. Super
FP mode
Flash Exposure Compensation ±3EV in
⅓, ½, or 1EV steps
Other Information Built-in flash
and wireless flash control available
(compatible with FL-50R and FL-36R)

Playback monitor

Type Multi-angle HyperCrystal II LCD
Dimensions 3in (7.6cm)
Resolution 920,000 pixels
Coverage 100%

Languages English; French; German;
Spanish; Italian; Russian; Czech, Dutch;
Danish; Polish; Portuguese; Swedish;
Norwegian; Finnish; Croatian; Slovenian;
Hungarian; Greek; Slovak; Turkish; Latvian;
Estonian; Lithuanian; Ukrainian; Serbian
(other languages available as Internet
downloads)
Live View 100% field of view; Exposure
adjustment preview; White balance
adjustment preview; Gradation auto
preview; 5x, 7x, & 10x magnification; MF/S-
AF & AF frame display; AF point display;
Shooting information; Histogram

Connections

External Interfaces USB 2.0; HDMI Type
C mini connector
Video Out Jack Yes (NTSC or PAL)
Other Flash hotshoe; PC flash sync
terminal; Optional IR remote control;
DC-in

Dimensions

Size 5.6 x 4.6 x 2.9in (143 x 117 x 75mm)
Weight 1.8lb (813g)

Included software

Olympus View 2

Power

Rechargeable 1620 mAh Li-ion battery
pack BLM-5

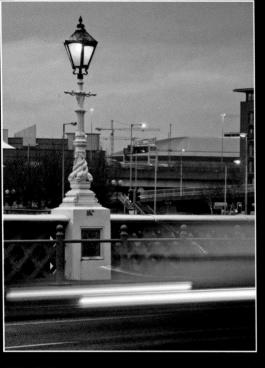

CITY LIGHT ⌃

Cities are often at their most photogenic in the evening, just before it gets completely dark. This occurs about half an hour after sunset, at which time there is still color in the sky, but the ambient light levels are low enough for any street lighting to stand out against the background. Because shutter speeds will be long, night photography is best done using a tripod and remote release to avoid camera shake. Start shooting east first as this will be the first part of the sky to turn black, and finish facing west. Typically, there is a window of about half an hour for good photography, but this varies with the seasons.

Settings
> *Focal length: 14mm*
> *Aperture: f/8*
> *Shutter speed: 1/30 sec.*
> *ISO: 100*

BLACK AND WHITE

Virtually all Four Thirds and Micro Four Thirds cameras have the ability to shoot in black and white, although this option will only affect JPEG files—Raw images will still be recorded in color. When shooting on film, photographers would use colored filters to lighten or darken tones in the image and some Four Thirds and Micro Four Thirds cameras have an option that allows you to mimic these. It is worth experimenting with the different settings to see how they affect your images—yellow, orange, and red filters can help darken the sky in a landscape, for example.

» PANASONIC LUMIX DMC-GH2 September 2010

PANASONIC LUMIX DMC-GH2 ✿
With the built-in flash raised.

Although there have been numerous Four Thirds and Micro Four Thirds cameras with video functionality, the Panasonic GH2 is commonly regarded as the camera that "got it right" in terms of shooting movies, but without neglecting the needs of stills photographers.

Sensor

The GH2 used a new 16.05 megapixel Live MOS Sensor. Bristling with advances over previous Four Thirds sensors, the sensor boasted a 3dB improvement in the suppression of noise, and to make the most of this new sensor Panasonic also improved its image processor. The Venus Engine FHD is capable of extracting the maximum detail from the sensor, as well as facilitating full HD video output. It also allowed the highest ISO setting of any Micro Four Thirds camera to date: set to its maximum ISO of 12,800, the GH2 can almost see in the dark.

Movies

The GH2 featured a full HD resolution of 1920 x 1080 pixels, recording at either 60i (NTSC) or 50i (PAL). There was also a 24p mode for a more "filmic" look, and the frame rate could be varied further to create a fast- or slow-motion effect.

Most intriguing of all was the EX Tele Conversion function. Digital sensors have a far greater resolution than is required for HD video, so the output of the sensor is usually interpolated down to produce the correct resolution. The GH2, however,

> **JARGON BUSTING: INTERPOLATION**
>
> Interpolation is a method of either increasing or decreasing the resolution of an image. This is done either by removing of pixels if the resolution needs to be reduced, or by inserting pixels if the resolution needs to be increased.

allowed this usually wasted resolution to be used to "zoom" in digitally, *without* any loss in image quality. So far, this is unique to Panasonic, although it is very likely that other manufacturers will follow suit.

The third dimension

Announced alongside the GH2 was the world's first interchangeable 3D lens—the Lumix G 12.5mm f/12. This new lens promised to minimize the time lag between capturing the left and right images, so a convincing 3D effect could be captured and viewed on Panasonic 3D VIERA televisions.

GH2 versus G2

EVF GH2's electronic viewfinder resolution increased slightly, from 800 x 600 pixels to 852 x 600 pixels.

LCD GH2 gained touch-sensitive controls for menu and shooting operations.

Body Minor button changes, including the replacement of the metering and film-mode buttons with customizable Fn buttons. Control dial moved from the hand grip to the rear of the camera; movie shooting and Q menu buttons moved from the top of the camera to the rear; new, smaller capacity battery (1200 mAh instead of 1250 mAh); combined AF mode and metering pattern dial.

Menu Revised design for menu screens.

CLASSIC STYLE «
The styling retained the "house style" seen on previous Panasonic Micro Four Thirds cameras.

Sensor
Resolution 16.05 megapixels (effective)
Type 4:3 aspect ratio High Speed Live MOS sensor

Image processor
Venus Engine FHD

Body
Construction Materials Plastic
Lens Mount Micro Four Thirds

Image sizes
Maximum 4608 x 3456 pixels
Minimum 1792 x 1792 pixels (when 3D lens is attached)

Storage media
SD memory card (SDHC/SDXC compatible)

File formats
Still Images JPEG (Fine; Normal); Raw (12-bit); Raw+JPEG; MPO (with 3D lens)
Movie Mode AVCHD; Time Motion JPEG

Focus
Type Contrast AF
Modes Single AF; Continuous AF; Manual Focus; Face Detection; AF Tracking; 1-area-focusing Touch
Focus Areas 1 or 23 area focusing
Focus Selection Automatic; Manual, Touch AF
Depth of Field Preview No

Exposure
Metering Type TTL with 144-zone multipattern

Metering Modes Intelligent Multiple; Center-weighted; Spot
Exposure Modes Auto; Program AE (**P**); Aperture Priority (**A**); Shutter Priority (**S**); Manual (**M**)
Scene Modes (still images) Portrait (Normal, Soft Skin, Outdoor, Indoor, and Creative); Scenery (Normal, Nature, Architecture, and Creative); Close-up (Flower, Food, Objects, and Creative); SCN (Peripheral Defocus, Night Portrait, Night Scenery, Sunset, Party, Sports, Baby 1 & 2, and Pet)
Scene Modes (movie mode) Portrait (Normal, Soft Skin, Outdoor, Indoor, and Creative); Scenery (Normal, Nature, Architecture, and Creative); Close-up (Flower, Food, Objects, and Creative); SCN (Peripheral Defocus, Night Portrait, Night Scenery, Sunset, Party, Sports, Baby 1 & 2, and Pet)
ISO Modes Auto/Manual; Intelligent ISO
ISO Range 160–12800
Exposure Compensation ±5EV in ⅓EV steps
Exposure Bracketing 3, 5, or 7 frames, ±3EV in ⅓, ⅔, or 1EV steps
ISO Bracketing 3, 5, or 7 frames, ±3EV in ⅓, ⅔, or 1EV steps

Shutter
Type Electronic focal-plane shutter
Shutter Speed 60 seconds–1/4000 sec.; Up to 2 minutes (Bulb)

Viewfinder
Type Electronic Live View Finder

Coverage 100%
Resolution Approx. 1,533,600 pixels
Magnification x1.42
Eyepoint Approx. 17.5mm
Diopter Adjustment -4.0 to +4.0

Drive system

Modes Single; Continuous Shooting
Max. Frame Rate 5fps (H)igh Speed;
3fps (M)edium Speed; 2fps (L)ow Speed
Max. Frame Burst 7 frames (Raw);
Compression ratio and resolution
dependent (JPEG)
Self Timer 2 seconds; 10 seconds;
10 seconds (3 images)

Flash

Built-in Flash Yes
Guide Number 45ft/13.9m @ ISO 100
Flash Modes Auto; Auto red-eye
reduction; Forced on; Forced off; Forced
on red-eye reduction slow sync; Slow sync
red-eye reduction
Sync Speed 1/160 sec.

Movie recording

Recording Format AVCHD; Motion JPEG
AVCHD Modes HD 1280 x 720 60p; Full
HD 1920 x 1080 60i
Motion JPEG Modes QVGA 320 x 240; VGA
640 x 480; WVGA 848 x 480; HD 1280 x 720
Frame Rate 30fps (NTSC); 25fps (PAL)
Maximum Recording Time Up to 120
minutes using AVCHD at FSH quality

Playback monitor

Type TFT LCD with touch panel
Dimensions 3in (7.6cm)
Resolution 460,000 pixels
Coverage 100%
Languages English; German; French;
Italian; Spanish; Polish; Czech; Hungarian;
Russian; Chinese (Traditional); Chinese
(Simplified); Dutch; Thai; Korean; Turkish;
Portuguese; Arabic; Persian; Japanese;
Swedish; Danish; Finnish; Greek
Live View Optional guidelines; Real-time
histogram

Connections

External Interfaces USB 2.0; HDMI Type C
mini connector; 2.5mm stereo mini jack;
AV connector
Other Flash hotshoe

Dimensions

Size 4.88 x 23.5 x 2.98in (124 x 89.6 x 76mm)
Weight 13.82oz (392g)

Included Software

PHOTOfunSTUDIO 6.0 BD Edition; SILKYPIX
Developer Studio 3.1 SE; Super LoiLoScope
(trial version)

Power

Rechargeable 1200 mAh Li-ion battery

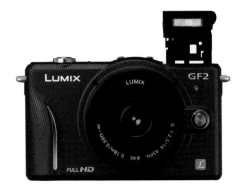

PANASONIC LUMIX DMC-GF2
A red GF2 with its built-in flash extended.

Camera technology does not stand still, and by late 2010 the GF1 was facing stiff competition from cameras such as Sony's NEX range. To fight back, Panasonic released the GF2.

Touch control

The most striking difference between the GF1 and GF2 is the reduction in the number of buttons and dials on the body of the newer camera. This makes the GF2 less intimidating than a full-blown digital SLR, and easier to pick up and use without reference to a manual.

Control of the GF2's various functions is achieved primarily using its touch-sensitive LCD and a new graphical user interface. The most appealing aspect of this touch-control system is the ability to select the focus point in a scene just by touching the display in the right place. This also applies when shooting movies, which allows sophisticated "pull-focus" effects to be achieved without fuss.

Movies

The GF2 also scores over the GF1 in its ability to shoot movies at full 60i/50i HD with a 1920 x 1080 pixel resolution, or 60p/50p HD movies at 1280 x 720 pixels. This requires the use of fast, high-capacity memory cards, and Panasonic recommend using a "class 4," or higher, SD card—a memory card that is slower than this will not be able to keep up as the video data is streamed from the sensor.

The GF2 can also record stereo sound, with a built-in wind-filter cutting out the extraneous sound caused by wind without the need for a muffler over the mic.

Artistic intent

When shooting film, it was necessary to shoot an entire roll before another could be inserted. If you only ever used one type of film, this would not be a problem, but it was far from ideal if you wanted one image to be in black and white, the next in color, and so on. Of course, with digital capture one image can be very different to the next.

The GF2 not only allows you to alter basic settings such as contrast and saturation, but also provides a range of presets such as Retro and Dynamic Art that help add an artistic gloss to pictures.

Live View is invaluable when using these, as you can preview how the effect will look before you commit yourself to creating the image.

Lenses

On release, the GF2 was available with a 14–42mm zoom and/or 14mm f/2.5 "pancake" lens. The GF1 was originally available with a 20mm f/1.7 pancake lens, which although small, is larger and heavier than the 14mm. However, the 20mm focal length is arguably more useful as a "day-

to-day" lens as its angle of view is very similar to a "standard" full-frame lens, and it has a wider maximum aperture than the 14mm. That said, the 14mm lens would be the landscape photographer's choice, as the combination of a compact, wide-angle lens and a small, lightweight camera makes it the ideal companion for long walks over rough terrain.

Any color you like...

Unlike Henry Ford's Model T motorcar, the GF2 can be bought with a silver or red body, as well as the more usual black. This helps to emphasize the fact that this camera is not meant to be intimidating, but fun to use and own.

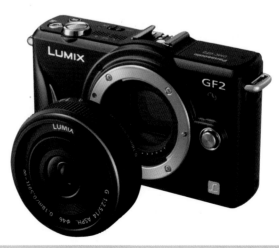

KIT LENS　　　　**»**
The GF2 is supplied with one of two lenses: a 14–42mm zoom or the 14mm "pancake" lens shown here.

Sensor
Resolution 12.1 megapixels (effective)
Type 4:3 aspect ratio High Speed Live MOS sensor

Image processor
Venus Engine FHD

Body
Construction Materials Metal
Lens Mount Micro Four Thirds

Image sizes
Maximum 4000 x 3000 pixels
Minimum 1440 x 1440 pixels (when 3D lens is attached)

Storage media
SD Memory Card (SD/SDHC/SDXC)

File formats
Still Images JPEG (Fine; Normal); Raw (12-bit); Raw+JPEG; MPO (with 3D lens)
Movie Mode AVCHD; Motion JPEG

Focus
Type Contrast AF
Modes Single AF; Continuous AF; Manual Focus; Face Detection; AF Tracking; 1-area-focusing Touch
Focus Areas 1 or 23 area focusing
Focus Selection Automatic; Manual, Touch AF
Depth of Field Preview No

Exposure
Metering Type TTL with 144-zone multipattern
Metering Modes Intelligent Multiple; Center-weighted; Spot
Exposure Modes Auto; Program AE (**P**); Aperture Priority (**A**); Shutter Priority (**S**); Manual (**M**)
Scene Modes Portrait; Soft Skin; Scenery; Architecture; Sports; Peripheral Defocus; Flower; Food; Objects; Night Portrait; Night Scenery; Illuminations; Baby 1 & 2; Pet; Party; Sunset
Scene Modes (movie mode) Portrait; Soft Skin; Scenery; Architecture; Sports; Flower; Food; Objects; Low-light; Party; Sunset
ISO Modes Auto/Manual; Intelligent ISO
ISO Range 100–6400
Exposure Compensation ±3EV in ⅓EV steps
Exposure Bracketing 3 or 5 frames ±2EV in ⅓ or ⅔EV steps

Shutter
Type Computerized focal-plane shutter
Shutter Speed 60 seconds–1/4000 sec.

Viewfinder
Type Optional DMW-LVF1 electronic viewfinder
Coverage 100%
Resolution Approx. 202,000 pixels
Magnification x1.04
Eyepoint Approx. 17.5mm
Diopter Adjustment -4.0 to +4.0

Drive system

Modes Single; Continuous Shooting
Max. Frame Rate 3.2fps (H)igh Speed;
2.6fps (M)edium Speed; 2fps (L)ow Speed
Max. Frame Burst 7 frames (Raw);
Compression ratio and resolution
dependent (JPEG)
Self Timer 2 seconds; 10 seconds;
10 seconds (3 images)

Flash

Built-in Flash Yes
Guide Number 20ft/6m @ ISO 100
Modes Auto; Auto red-eye reduction;
Forced on; Forced on red-eye reduction
slow sync; Slow sync red-eye reduction
Sync Speed 1/160 sec.

Movie recording

Recording Format AVCHD; QuickTime
Motion JPEG
AVCHD Modes HD 1280 x 720 60i;
Full HD 1920 x 1080 60p
Motion JPEG Modes QVGA 320 x 240; VGA
640 x 480; WVGA 848 x 480; HD 1280 x 720
Frame Rate 30fps (NTSC); 25fps (PAL)
Maximum Recording Time Up to 130
minutes using Motion JPEG at HD quality

Playback monitor

Type Multi-angle HyperCrystal LCD with
touch panel
Dimensions 3in (7.6cm)
Resolution 460,000 pixels
Coverage 100%
Languages English; Japanese; German;
French; Italian; Spanish
Live View Optional Guide lines; Real-time
histogram

Connections

External Interfaces USB 2.0; HDMI Type
C mini connector; AV Digital Out
Other Flash hotshoe

Dimensions

Size 4.44 x 2.67 x 1.29in (113 x 68 x 33mm)
Weight 9.35oz (265g)

Included software

PHOTOfunSTUDIO 6.0 HD Edition; SILKYPIX
Developer Studio 3.1 SE; Super LoiLoScope
(trial version)

Power

Rechargeable 1010 mAh Li-ion battery
DMW-BLD10

Settings
> *Focal length: 14mm*
> *Aperture: f/8*
> *Shutter speed: 1/250 sec.*
> *ISO: 100*

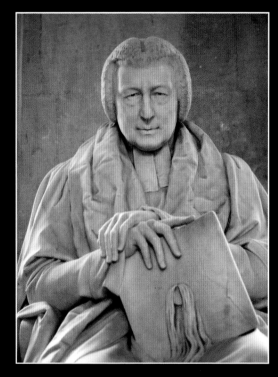

Settings
> *Focal length: 80mm*
> *Aperture: f/3.5*
> *Shutter speed: 1/100 sec.*
> *ISO: 1000*

EYE CONTACT ⌃

A portrait in which the subject is looking directly at the camera is very powerful and commands attention. For this reason it is important to focus correctly on the eyes—it can look very odd if they are even slightly out of focus. Keeping the eyes in focus is important whether the subject is a person, a pet, or, as in this case, a statue. This shot was particularly tricky as the light level was low and I couldn't use a tripod. As a result, I had to use a wide aperture to keep my shutter speed fast enough to avoid camera shake. I made certain that the focus point was precisely on the eyes, not worrying too much about anything else being slightly soft.

6 » OLYMPUS E-PL2 January 2011

OLYMPUS E-PL2
With improved LCD and rear control wheel.

The E-PL2 is an update of the E-PL1, although it should not necessarily be seen as a replacement: the two cameras were designed to sit side by side in the Olympus line-up. At the same time as the launch of the cameras, the digital PEN range was augmented by new accessories.

The Penpal PP-1 is a Bluetooth device that can used to transmit pictures wirelessly to other Bluetooth devices, and resize them so that they are Internet ready.

The second accessory is the MAL-1 macro light, which uses two long, flexible LED lights to light macro subjects. Both accessories plug into the EVF/Accessory port found on the E-PL2.

E-PL2 versus E-PL1

Dimensions The E-PL1 and E-PL2 are similar in size, but the E-PL2 is heavier.

LCD The resolution of the screen is much improved, jumping from a 2.7-inch, 230,000-pixel unit on the E-PL1, to 3-inches and 460,000 pixels on the E-PL2.

Design The E-PL2 is closer to the E-P1 and E-P2 in appearance, with a handgrip that is arguably more comfortable to use than the E-PL1's. The E-PL2 also has a rear control wheel and a larger shutter-release button.

Remote release The E-PL2 has a USB port that supports the use of the optional RM-UC1 remote release.

ISO Maximum ISO is raised to 6400, compared to ISO 3200 on the E-PL1. The base ISO is increased from ISO 100 to 200.

Shutter speed Flash sync speed increased to 1/180 sec., and maximum overall shutter speed increased to 1/4000 sec.

LIGHT »
The ability to shoot at a high ISO is invaluable in low-light situations.

Settings
> *Focal length: 50mm*
> *Aperture: f/14*
> *Shutter speed: 1.6 sec.*
> *ISO: 640*

Sensor
Resolution 12.3 megapixels (effective)
Type 4:3 aspect ratio High Speed Live MOS sensor

Image processor
TruePic V

Body
Construction Materials Metal
Lens Mount Micro Four Thirds

Image sizes
Maximum 4032 x 3024 pixels
Minimum 640 x 480 pixels

Storage media
SD Memory Card (SD/SDHC/SDXC)

File formats
Still Images JPEG (Fine; Normal); Raw (12-bit); Raw+JPEG
Movie Mode AVI Motion JPEG

Focus
Type High-Speed Imager AF
Modes Single AF; Continuous AF; Manual Focus; Single AF+MF
Focus Areas 11 points (Automatic and Manual selection)
Focus Selection Automatic; Manual
Depth of Field Preview No

Exposure
Metering Type TTL 324-zone multipattern
Metering Modes ESP light metering; Center-weighted; Spot (Approx. 2%); Highlight Spot; Shadow Spot

Exposure Modes i-Auto; Program (**P**); Aperture Priority (**A**); Shutter Priority (**S**); Manual (**M**)
Scene Modes Portrait; e-Portrait; Landscape; Landscape with Portrait; Sport; Night; Night with Portrait; Children; High Key; Low Key; DIS mode; Macro; Nature Macro; Candle; Sunset; Documents; Panorama; Fireworks; Beach & Snow; Fisheye Converter; Wide Converter; Macro Converter
Art Filters Pop Art; Soft Focus; Grainy Film; Pin Hole; Diorama; Dramatic Tone
ISO Modes Auto/Manual
ISO Range 200–6400 (Auto); 200–6400 in ⅓ or 1EV steps (Manual)
Exposure Compensation ±3EV in ⅓, ⅔, or 1EV steps
Exposure Bracketing 2, 3, or 5 frames in ±⅓, ½, ⅔, or 1EV steps; 7 frames in ⅓, ½, or ⅔EV steps
ISO Bracketing 3 frames in ±⅓, ⅔, or 1EV steps

Shutter
Type Computerized focal-plane shutter
Shutter Speed 60 seconds–1/4000 sec.; Up to 8 minutes (Bulb)

Image stabilizer
Type Sensor shift (still image); Digital shift (movie mode)
Compensation Range Three modes: IS 1, IS 2, or IS 3

Viewfinder

Type Optional externally fitted VF-2
electronic viewfinder
Coverage 100%
Magnification x1.15
Eyepoint Approx. 18mm
Diopter Adjustment -3.0 to +1.0

Drive system

Modes Single; Sequential Shooting
Max. Frame Rate 3fps
Max. Frame Burst 10 frames (Raw);
Compression ratio and resolution
dependent (JPEG)
Self Timer 2 seconds; 12 seconds

Flash

Built-in Flash Yes
Guide Number 33ft/10m @ ISO 100
Modes Auto; Manual; Red-eye reduction;
Red-eye reduction slow sync 1st curtain;
Slow sync 1st curtain; Slow sync 2nd
curtain
Sync Speed 1/180 sec.; 1/4000 sec. Super
FP mode
Flash Exposure Compensation ±3EV
in ⅓, ½, and 1EV steps

Movie recording

Recording Format AVI Motion JPEG
Modes HD 1280 x 720; SD 640 x 480
Frame Rate 30fps
Maximum Recording Time HD 7 minutes;
SD 14 minutes
Sound Stereo PCM/16 bit (44.1kHz)

Playback monitor

Type Multi-angle HyperCrystal LCD
Dimensions 3in (7.6cm)
Resolution 460,000 pixels
Coverage 100%
Languages 34 including English, Korean,
Simplified Chinese and Traditional Chinese
Live View 100% field of view; Exposure
adjustment preview; White balance
adjustment preview; Gradation auto
preview; Face detection preview (up to 8
faces); Optional grid line overlay; 7x,10x,
and 14x magnification; Perfect shot
preview; Shooting information; Histogram

Connections

External Interfaces USB 2.0; HDMI Type C
mini connector; Video-out; Optional remote
cable RM-UC1
Other Flash hotshoe; Dedicated multi-
connector

Dimensions

Size 4.5 x 2.86 x 1.65in (115.5 x 72.7 x 42mm)
Weight 0.7lb (317g)

Included software

Olympus Viewer 2

Power

Rechargeable 1620 mAh Li-ion battery
pack BLS-5

Chapter 7
CONSOLIDATION

PANASONIC LUMIX DMC-G3 ⌃
In white—one of four available body colors.

At first glance, the G3 appears to merely be a refinement of the G2 released in 2010, albeit in a smaller, more contemporary, sculpted body. Many of the features found on the earlier camera are present, including the articulated LCD with touch-screen controls. However, at the heart of the G3 is a new, 16-megapixel sensor allied to a new variation of the Venus Engine processor, the FHD. It is this combination that helps achieve what Panasonic claims is a vastly improved level of noise in images throughout the ISO range, up to the G3's maximum of ISO 6400.

Focusing

The updated Venus Engine is responsible for the G3's improved autofocus and frame rate compared to the G2. Panasonic claims that the G3 has the world's fastest contrast-AF system, which is able to match phase-detection systems in terms of speed, but with a greater level of accuracy. The increase in detection speed has been achieved by doubling the AF drive speed from 60fps to 120fps.

As first seen on the G2, the G3 has touch focusing that allows precise focus control by pressing the rear LCD screen. A new Pinpoint AF function allows you to achieve more accurate focusing by enlarging the focus area. In manual focus a Focus-assist mode allows you to enlarge the focus area 1x, 4x, 5x, or 10x. Usefully, at 4x magnification the enlarged area can be viewed as an overlay on the main image, so you can still see the composition in its entirety.

Usability

The G3 can be used as a fully manual camera, but if you want to just pick it up, point, and shoot, the new iA+ mode will help you do just that. Fully automatic modes often lock you out of a camera's creative functions, but the G3's iA+ mode does not: it allows you to alter the defocus

area, apply exposure compensation, and change the white balance as desired, but still have the safety net of the usual automated functions. iA+ is available in both still and movie shooting modes.

Image effects

The look of your images can be radically altered by selecting one of the Creative Control options. These are similar to the Art Filters found on Olympus cameras, with the G3 offering Expressive, Retro, High Key, Sepia, and High Dynamic options. Although similar functions can be found on other Panasonic Micro Four Thirds cameras, exposure compensation can now also be applied when using a Creative Control.

In addition, the G3 has a range of image controls known as Photo Styles. These allow you to create images with certain contrast, sharpness, saturation, and noise characteristics. Standard and Natural will give you flatter, more naturalistic colors, while Vivid increases the saturation and contrast for added punch. If you enjoy black-and-white photography, then Monochrome will allow you to achieve this in-camera. Finally, there are Photo Styles for Scenery and Portrait that will adjust the saturation and contrast to best suit landscape and portrait subjects.

FLEXIBLE LCD »
Like the G2, the G3 has a useful, articulated LCD screen.

Sensor
Resolution 16 megapixels (effective)
Type 4:3 aspect ratio Live MOS sensor

Image processor
Venus Engine FHD

Body
Construction Materials Aluminum
Lens Mount Micro Four Thirds

Image sizes
Maximum 4592 x 3448 pixels
Minimum 1712 x 1712 pixels

Storage media
SD Memory Card (SD/SDHC/SDXC)

File formats
Still Images JPEG (Fine; Normal); Raw
(12-bit); Raw+JPEG; MPO (when using
optional 3D lens)
Movie Mode AVCHD; QuickTime
Motion JPEG

Focus
Type Contrast AF
Modes Single AF; Continuous AF; Face
Detection; AF Tracking; Pinpoint
Focus Areas 1 or 23 area focusing
Focus Selection Auto; Manual, Touch AF

Exposure
Metering Type TTL 144-zone multipattern
Metering Modes Intelligent multiple;
Center-weighted; Spot
Exposure Modes Programmed AE (**P**);
Aperture Priority (**A**); Shutter Priority (**S**);
Manual (**M**)
Scene Modes (still images) Portrait,
Soft Skin, Scenery, Architecture, Sports,
Peripheral Defocus, Flower, Food,
Objects, Night Portrait, Night, Scenery,
Illuminations, Baby 1 & 2, Pet, Part, and
Sunset
Scene Modes (movie mode) Portrait, Soft
Skin, Scenery, Architecture, Sports, Flower,
Food, Objects, Low-light, Part, and Sunset
ISO Range 100–6400 in ⅓EV steps
Exposure Compensation ±5EV in ⅓EV steps
Exposure Bracketing 3, 5 or 7 frames ±3EV
in ⅓, ⅔, or 1EV steps

Shutter
Type Electronic focal-plane shutter
Shutter Speed Still images 60 seconds–
1/4000 sec.; Bulb (up to 2 minutes);
Motion images 1/16000–1/30 sec. (NTSC),
1/16000–1/25 sec. (PAL)

Viewfinder
Type Electronic Live View Finder
Coverage 100%
Pixels Approximately 1,440,000
Magnification x1.4
Eyepoint Approx. 17.5mm
Diopter Adjustment -4.0 to +4.0

Drive system

Modes Single; Continuous Shooting
Max. Frame Rate 20fps (at 4 megapixel
resolution; 4fps (H)igh Speed;
3fps (M)edium; 2fps (L)ow
Max. Frame Burst 7 frames (RAW);
Compression ratio and resolution
dependant (JPEG)
Self Timer 2 seconds; 10 seconds; 10
seconds (3 images)

Flash

Built-in Flash Yes
Guide Number 34ft/10.5m @ ISO 100
Modes Auto; Auto red-eye reduction;
Forced on; Forced on red-eye reduction
slow sync; Slow sync red-eye reduction;
Forced off; 1st curtain sync; 2nd curtain
sync
Sync Speed 1/160 sec.
Flash Exposure Compensation ±2EV in
⅓EV steps

Movie recording

Recording Format AVCHD; QuickTime
Motion JPEG
AVHCD Mode Full HD 1920 x 1080 60i
(NTSC)/50i (PAL); HD 1280 x 720 60p
(NTSC)/50p (PAL)
Motion JPEG Modes QVGA 320 x 240; VGA
640 x 480; HD 1280 x 720
Frame Rate 30fps (NTSC); 25fps (PAL)
Maximum Recording Time Up to 100
minutes using AVCHD at FSH quality

Playback monitor

Type Multi-angle TFT LCD with touch panel
Dimensions 3in (7.6cm)
Resolution 460,000 pixels
Coverage 100%
Languages English; Japanese; German;
French; Italian; Spanish
Live View Three optional guidelines; Real-
time histogram; 2x and 4x magnification

Connections

External Interfaces USB 2.0; HDMI Type C
mini connector; 2.5mm mini-jack
Other Flash hotshoe

Dimensions

Size 4.54 x 3.3 x 1.84in (115 x 83.6 x 46.7mm)
Weight 19.2oz (544g)

Included software

PHOTOfunSTUDIO 6.2 HD Edition;
SILKYPIX® Developer Studio 3.1 SE; Super
LoilLoScope (trial version)

Power

Rechargeable 1010 mAh li-ion battery

PANASONIC LUMIX DMC-GF3 ⌃
In black with in-built flash raised.

The trend for ever-smaller Micro Four Thirds cameras continues with the GF3, which is approximately 17% smaller and 15% lighter than its predecessor, the GF2, making it the smallest and lightest Micro Four Thirds camera available at the time of writing. It would have been the smallest and lightest interchangeable-lens camera in the world had that title not been stolen almost immediately by the Sony NEX-C3. Remarkably, when fitted with a pancake lens, the GF3 is not that different in size to Panasonic's popular LX5 compact digital camera.

Downsizing

The GF3's reduction in size has come at a cost, however. For a start, the GF3 does not have a flash hotshoe and so does not accept external flash units. There is a built-in flash that pops up from a housing directly over the lens mount, but with a guide number of 20ft/6.3m it is not particularly powerful, although it is still useful as a fill-in light for contrast control.

Another drawback is that removing the hotshoe (and the accessory port below it) means that the GF3 is not compatible with the Panasonic DMW-LVF1 viewfinder, so setting camera functions and image composition is achieved solely by using the rear LCD screen.

The rear controls are different to the GF2 as well. The separate thumb-dial of the GF2 has been replaced by a dial wrapped around the rear four-way controller. Gone too is a built-in stereo microphone, replaced by a far simpler (and therefore less expensive) mono device.

Improvements

Despite some sacrifices, there has also been much added to the GF3 to make it a very useful photographic tool. It shares numerous features with the G3, such as the iA+ shooting mode, a picture-in-picture manual focus magnification mode, and Pinpoint AF. Unique to the GF3, however,

is the ability to extract a still frame from movie playback and save it as a (low resolution) JPEG file. Like the G3, the GF3 is also available in a variety of colors: black, red, and a very contemporary-looking white.

Thanks to the new Panasonic Venus Engine image processor, the maximum frame rate and AF focus speeds are improved compared to the GF2, and are as good as the GF3's more expensive stablemates, despite it being Panasonic's entry-level Micro Four Thirds camera.

Special effects

The GF3 shares five of the Creative Control modes found on the G3, but has one unique trick of its own: Miniature mode, which recreates the effect of using a tilt-and-shift lens to produce a minimal depth of field. This can have the effect of making a scene look like it is a small-scale model, hence the name. The effect works best if you create a simple composition, with your subject placed precisely in the sharpest part of the picture.

JARGON BUSTING:
TILT-AND-SHIFT LENSES

A tilt-and-shift lens allows you to move the lens elements up and down (or left and right) or tilt the lens so that the front is no longer parallel to the camera. This latter technique can be used to control depth of field, either increasing it or reducing it substantially—the effect replicated by the GF3's Miniature mode. Neither Panasonic nor Olympus produce a true tilt-and-shift lens, although Lensbaby (www.lensbaby.com) produce the Lensbaby Tilt Transformer that can achieve a similar effect on a Micro Four Thirds camera, using a Nikon lens.

COLOR ❯❯
A top-down and rear view of the GF3 in the optional red finish.

Sensor
Resolution 12.1 megapixels (effective)
Type 4:3 aspect ratio High Speed Live MOS sensor

Image processor
Venus Engine FHD

Body
Construction Materials Aluminum
Lens Mount Micro Four Thirds System

Image sizes
Maximum 4000 x 3000 pixels
Minimum 1440 x 1440 pixels (with 3D lens)

Storage media
SD Memory Card (SD/SDHC/SDXC)

File formats
Still Images JPEG (Fine; Normal); Raw 12-bit; Raw+JPEG; MPO (with 3D lens)
Movie Mode AVCHD; QuickTime Motion JPEG

Focus
Type Contrast AF
Modes Single AF; Continuous AF; Manual Focus; Face Detection; AF Tracking; Quick AF; AF+MF; Touch shutter; Touch AF Assist
Focus Areas 1 or 23 area focusing
Focus Selection Auto; Manual, Touch AF

Exposure
Metering Type TTL 144-zone multipattern
Metering Modes Intelligent multiple; Center-weighted; Spot
Exposure Modes Program AE (**P**); Aperture Priority (**A**); Shutter Priority (**S**); Manual (**M**)
Scene Modes (still images) Portrait, Soft Skin, Scenery, Architecture, Sports, Peripheral Defocus, Flower, Food, Objects, Night Portrait, Night, Scenery, Illuminations, Baby 1 & 2, Pet, Part, and Sunset
Scene Modes (movie mode) Portrait, Soft Skin, Scenery, Architecture, Sports, Flower, Food, Objects, Low-light, Part, and Sunset
ISO Modes Auto/Intelligent ISO
ISO Range 160–6400
Exposure Compensation ±3EV in ⅓EV steps
Exposure Bracketing 3 or 5 frames ±3EV in ⅓ or ⅔EV steps

Shutter
Type Computerized focal-plane shutter
Shutter Speed 60 seconds–1/4000 sec.; Motion images 1/16000–1/30 sec. (NTSC), 1/16000–1/25 sec. (PAL)

Drive system
Modes Single; Continuous Shooting
Max. Frame Rate 3.8fps (H)igh Speed; 2.8fps (M)edium; 2fps (L)ow
Max. Frame Burst 7 frames (RAW); Compression ratio and resolution dependant (JPEG)
Self Timer 2 seconds; 10 seconds; 10 seconds (3 images)

Flash

Built-in Flash Yes
Guide Number 20ft/6.3m @ ISO 100
Modes Auto; Auto red-eye reduction;
Forced on; Forced on red-eye reduction
slow sync; Slow sync red-eye reduction;
Forced off; 1st. Curtain sync
Sync Speed 1/160 sec.

Movie recording

Recording Format AVCHD; QuickTime
Motion JPEG
AVHCD Mode Full HD 1920 x 1080 60i
(NTSC)/50i (PAL); HD 1280 x 720 60p
(NTSC)/50p (PAL)
Motion JPEG Modes QVGA 320 x 240; VGA
640 x 480; HD 1280 x 720
Frame Rate 30fps (NTSC); 25fps (PAL)

Playback monitor

Type Multi-angle TFT LCD with touch
panel
Dimensions 3in (7.6cm)
Resolution 460,000 pixels
Coverage 100%
Languages English; Japanese; German;
French; Italian; Spanish
Live View Three optional guidelines; Real-
time histogram; 2x and 4x magnification

Connections

External Interfaces USB 2.0; HDMI Type C
mini connector; AV Digital Out

Dimensions

Size 4.24 x 2.64 x 1.3in (108 x 67.1 x 32.5mm)
Weight 9.31oz (265g)

Included software

PHOTOfunSTUDIO 6.2 HD Edition;
SILKYPIX® Developer Studio 3.1 SE; Super
LoilLoScope (trial version)

Power

Rechargeable 940 mAh li-ion battery

Settings
> *Focal length: 200mm*
> *Aperture: f/11*
> *Shutter speed: 1/6 sec.*
> *ISO: 100*

STORIES ⌃

A successful photograph is one that is able to command the attention of a viewer and spark their imagination. This can often be achieved by allowing that viewer to "write" his or her own story into a photo. This sculpture of two people, a couple, has them looking out to sea. Because I allowed space around the figures it is up to the viewer to imagine what the couple are looking at, what their thoughts and emotions are, and even what their future may hold. Because there are no other distractions in the picture, the viewer's mind is free to ponder these questions.

7 » OLYMPUS E-P3 August 2011

OLYMPUS E-P3 ⌃
The camera is also available in silver and white.

The E-P3 is the third generation of the "high-end" digital PEN cameras, and replaces 2009's highly regarded E-P2. The E-P3 is arguably the most professional digital PEN released to date, with a feature set that puts many digital SLRs to shame.

Processing power

Key to the success of the E-P3 is the newest iteration of Olympus' TruePic image processor; the VI. The processor works to extract as much image information from the sensor as possible, which means that the images captured by the E-P3 are sharper and have more "punch" than those created by its predecessors.

Another improvement is in noise control: TruePic VI is better able to reduce the occurrence of noise in images. This has allowed Olympus (in common with the simultaneously released E-PL3 and E-PM1)

to increase the maximum ISO achievable to 12,800, the highest on any digital PEN camera to date. The TruePic VI processor can also work its magic on video footage, and has ability to reduce image noise as the data is compressed and saved, resulting in a "cleaner" movie.

Autofocusing

It is in the speed of the E-P3's autofocus that the new TruePic image processor really makes its mark. The FAST (or Frequency Acceleration Sensor Technology) AF system is the quickest contrast detection AF on any Micro Four Thirds camera to date. Indeed, Olympus claims that it even beats a traditional phase-detection system for both speed and accuracy—a remarkable achievement.

To speed things up further there is a Full Time AF mode that constantly refocuses so

JARGON BUSTING: OLED

OLED stands for Organic Light Emitting Diode, a comparatively new display technology that is slowing gaining acceptance. The big advantage over existing screen types, such as LCD, is that an OLED screen require less power, which helps to prolong battery life.

that the camera is ready to capture a sharp shot as soon as the shutter-release button is pressed. Of course there is a downside to this: because the lens AF motor is constantly active, Full Time AF will drain the camera battery more quickly than normal AF. Fortunately this is a function that can be turned off as required.

Ergonomics

The E-P3 is easier to use than its predecessors thanks to its new touch-sensitive OLED screen (a feature not found on the E-PL3 or E-PM1). This allows you to quickly flick through your pictures, zoom in and zoom out, as well as control camera functions such as the focus point and shutter release.

The screen itself has an increase in contrast and higher color fidelity than previous digital PEN screens. The graphic user interface (GUI) has also had a subtle makeover, making it easier to find your way around the E-P3's various menus.

To improve the handling, the E-P3 can be customized by removing the handgrip and replacing it with the optional MCG-2 grip. This is sculpted to make it easier to hold the E-P3, and will be most effective when using telephoto lenses.

Flash

The E-P3 improves on the E-P2 with the inclusion of an built-in flash. Although it is not a powerful unit (guide number 33ft/10m at ISO 200), it is still useful as a fill-in light. External flash units can also be fitted to the hotshoe, as can the optional VF-2 viewfinder, which reduces reliance on the OLED screen for composition.

OLYMPUS E-P3 〈〈
The E-P3 has a very "clean" design.

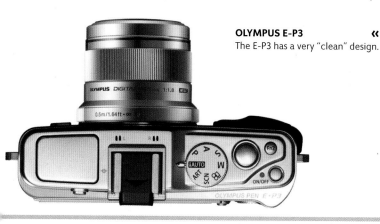

Sensor

Resolution 12.3 megapixels (effective)
Type 4:3 aspect ratio High Speed Live MOS sensor

Image processor

TruePic VI

Body

Construction Materials Metal
Lens Mount Micro Four Thirds

Image sizes

Maximum 4032 x 3024 pixels
Minimum 1024 x 768 pixels

Storage media

SD Memory Card (SD/SDHC/SDXC)

File formats

Still Images JPEG (Fine; Normal); Raw (12-bit); Raw+JPEG; MPO (3D)
Movie Mode AVI Motion JPEG; AVHCD

Focus

Type High-Speed contrast-detection AF
Modes Single AF; Continuous AF; Manual Focus; Single AF+MF; AF Tracking; Face detection
Focus Areas 35 points (Automatic and Manual selection)
Focus Selection Automatic; Manual
Depth of Field Preview No

Exposure

Metering Type TTL 324-zone multipattern
Metering Modes ESP light metering; Center-weighted; Spot (approx. 2%);
Highlight Spot; Shadow Spot
Exposure Modes i-Auto; Program AE (**P**); Aperture Priority (**A**); Shutter Priority (**S**); Manual (**M**); Multi exposure
Scene Modes Portrait, e-Portrait, Landscape, Landscape with Portrait, Macro, Sports, Night Scene, Night Scene with portrait, Children, High Key, Low Key, Digital Image Stabilization, Nature Macro, Candle, Sunset, Documents, Panorama, Fireworks, Beach and Snow, Fisheye converter, Macro converter, 3D, and Wide converter
Art Filters Pop Art, Soft Focus, Pale and Light color, Light Tone, Grainy Film, Pinhole, Diorama, Cross Process, Dramatic Tone, Gentle Sepia, Starlight, and White Edge
ISO Modes Auto/Manual
ISO Range 200–12,800
Exposure Compensation ±3EV in ⅓, ½, or 1EV steps
Exposure Bracketing 2, 3, or 5 frames in ±⅓, ⅔, or 1EV steps; 7 frames in ⅓, ½, or ⅔EV steps
ISO Bracketing 5 frames in ±⅓, ½, or 1EV steps

Shutter

Type Computerized focal-plane shutter
Shutter Speed 60 seconds–1/4000 sec.; Up to 30 minutes (Bulb); Multi-exposure

Image stabilizer

Type Sensor shift (still image); Digital shift (movie mode)

Viewfinder

Type Optional externally fitted VF-2 electronic viewfinder
Coverage 100%
Magnification x1.15
Eyepoint Approx. 18mm
Diopter Adjustment -3.0 to +1

Drive system

Modes Single; Sequential Shooting
Max. Frame Rate 3fps (H)igh Speed
Max. Frame Burst 17 frames (RAW); Compression ratio and resolution dependant (JPEG)
Self Timer 2 seconds; 12 seconds

Flash

Built-in Flash Yes
Guide Number 33ft/10m at ISO 200
Modes Auto; Manual; Red-eye Reduction; Red-eye Reduction Slow Sync; Slow Sync 2nd Curtain; Fill-in; Off
Sync Speed 1/180 sec.
Flash Exposure Compensation ±3 EV in ⅓, ½, or 1EV steps

Movie recording

Recording Format AVI Motion JPEG; AVHCD
Modes Full HD 1920 x 1080 (60i); HD 1280 x 720 (60p); HD 1280 x 720 (AVI Motion JPEG); SD 640 x 480 (AVI Motion JPEG)
Maximum Recording Time 29 minutes
Sound Stereo PCM/16-bit (48kHz); Wave Format Base (AVI Motion JPEG)

Playback monitor

Type OLED Touch Panel
Dimensions 3in (7.6cm)
Resolution 610,000 pixels
Coverage 100%
Languages English; French; German; Spanish; Italian; Russian; Czech; Dutch; Danish; Polish; Portuguese; Swedish; Norwegian; Finnish; Croatian; Slovenian; Hungarian; Greek; Slovak; Turkish; Latvian; Estonian; Lithuanian; Ukrainian; Serbian
Live View 100% field of view; Shooting information; Histogram; Face/Eye detection

Connections

External Interfaces USB 2.0; HDMI Type C mini connector; USB Video-out; Eye-Fi card compatible; Bluetooth compatible (with optional PENPAL adapter)
Other Flash hotshoe; Exchangeable grip

Dimensions

Size 4.8 x 2.72 x 1.35in (122 x 69.1 x 34.3mm)
Weight 11.3oz (321g)

Included software

Olympus Viewer 2

Power

Rechargeable li-ion battery pack

» OLYMPUS E-PL3 Autumn 2011

OLYMPUS E-PL3 ⌃
Like the E-P3 and E-PM1, the E-PL3 is available in a number of different colours, including black.

Just as the E-P3 is an update of the E-P2, so the Olympus E-PL3 is an update of the E-PL2. Refreshingly, even though the E-PL3 is a less expensive camera than the E-P3, it shares many of the same features. Most notably, the sensor and image processor are the same, so the image quality should be no different. The FAST AF system has also been carried over. On the downside, there are fewer art filters, but these are effects that could be achieved in post-production if necessary.

Screen
One key feature that separates the E-PL3 from its more expensive stablemate is the touch-sensitive OLED: the E-PL3 relies on a more conventional LCD screen instead. The resolution of the E-PL3's screen is also smaller, at 460,000 pixels (rather than 610,000 pixels). This may seem initially disappointing, but the resolution drop is more than made-up for by the fact that the LCD screen can be tilted up or down. This makes using the E-PL3 above head height, or low to the ground a far easier process and, to date, the E-PL3 is the only digital PEN camera with this facility.

Size
The E-PL3 is smaller than the E-P3, and it is also smaller and lighter than its predecessor, the E-PL2, with a reduction of 25% in size and 17% in weight. One of the features sacrificed to this slimming down process is the removal of the built-in flash. Instead, the E-PL3 is supplied with an external flash that clips into the hotshoe.

The rear controls of the E-PL3 have also been revised in comparison to the E-PL2. Although the same basic controls are all still there—including the control wheel—their size and position have all been altered, arguably into a more logical and intuitive configuration.

New lenses
Olympus has not confined itself to new cameras for 2011: at the same time as the E-P3 was announced, so too were two new prime lenses, a 12mm f/2 lens, and a 45mm f/1.8 lens. The outer casing of both

lenses is constructed from metal, in a bright silver finish that gives them a pleasing retro feel. The two lenses also have near-silent auto focusing, making them suitable for use when shooting video.

The 12mm lens is the more expensive of the two, but uses an exotic combination of highly-refractive glass and aspherical elements for improved image quality. The lens is compatible with the FAST AF system, but switching to manual focusing is quickly achieved by pulling the focus ring back toward the camera. This mechanism rather neatly reveals a distance scale, which is hidden when the lens is set to focus automatically.

With a maximum aperture of f/1.8, the new 45mm lens is slightly faster than the 12mm. It delivers an angle of view that is roughly equivalent to a 90mm "full-frame" lens, which is considered the ideal focal length for portraiture. Because the lens has such a wide aperture it makes it far easier to create a shallow depth of field. This will allow you to keep backgrounds out of focus so they are less distracting.

OLYMPUS E-PL3 ⌄
The rear controls have been rearranged.

DIGITAL ED 45MM F/1.8 LENS ⌃
The focal length and fast aperture of this new, retro style lens makes it ideal for portraiture.

Sensor
Resolution 12.3 megapixels (effective)
Type 4:3 aspect ratio High Speed Live MOS sensor

Image processor
TruePic VI

Body
Construction Materials Metal
Lens Mount Micro Four Thirds

Image sizes
Maximum 4032 x 3024 pixels
Minimum 1024 x 768 pixels

Storage media
SD Memory Card (SD/SDHC/SDXC)

File formats
Still Images JPEG (Fine; Normal); Raw (12-bit); Raw+JPEG; MPO (3D)
Movie Mode AVI Motion JPEG; AVHCD

Focus
Type High-speed contrast-detection AF
Modes Single AF; Continuous AF; Manual Focus; Single AF+MF; AF Tracking; Face detection
Focus Areas 35 points (Automatic and Manual selection)
Focus Selection Automatic; Manual
Depth of Field Preview No

Exposure
Metering Type TTL 324-zone multipattern
Metering Modes ESP light metering; Center-weighted; Spot (approx. 2%); Highlight Spot; Shadow Spot
Exposure Modes i-Auto; Program AE (**P**); Aperture Priority (**A**); Shutter Priority (**S**); Manual (**M**); Multi exposure
Scene Modes Portrait, e-Portrait, Landscape, Landscape with Portrait, Macro, Sports, Night Scene, Night Scene with Portrait, Children, High key, Low key, Digital Image Stabilization, Nature Macro, Candle, Sunset, Documents, Panorama, Fireworks, Beach and Snow, Fisheye converter, Macro converter, and 3D
Art Filters Pop Art, Soft Focus, Grainy Film, Pinhole, Diorama, Dramatic Tone, Starlight, and White Edge
ISO Modes Auto/ISO
ISO Range 200–12,800
Exposure Compensation ±3EV in ⅓, ½, or 1EV steps
Exposure Bracketing 2, 3, or 5 frames in ±⅓, ⅔, or 1 EV steps; 7 frames in ⅓, ½, or ⅔EV steps
ISO Bracketing 5 frames in ±⅓, ½, or 1EV steps

Shutter
Type Computerized focal-plane shutter
Shutter Speed 60 seconds–1/4000 sec.; Up to 30 minutes (Bulb)

Image stabilizer

Type Sensor shift (still image); Digital shift (movie mode)

Viewfinder

Type Optional externally fitted VF-2 electronic viewfinder
Coverage 100%
Magnification x1.15
Eyepoint Approx. 18mm
Diopter Adjustment -3.0 to +1

Drive system

Modes Single; Sequential Shooting
Max. Frame Rate 4.1fps (5.5fps when IS is switched off)
Self Timer 2 seconds; 12 seconds

Flash

Built-in Flash No (external flash supplied)
Guide Number 33ft/10m at ISO 200
Flash Modes Auto; Manual; Red-eye Reduction; Red-eye Reduction Slow Sync; Slow Sync 2nd Curtain; Fill-in; Off
Sync Speed 1/160 sec
Flash Exposure Compensation ±3 EV in ⅓, ½, or 1EV steps

Movie recording

Recording Format AVI Motion JPEG; AVHCD
Modes Full HD 1920 x 1080 (60i); HD 1280 x 720 (60p); HD 1280 x 720/30fps (AVI Motion JPEG); SD 640 x 480 (AVI Motion JPEG)
Maximum Recording Time 29 minutes
Sound Stereo PCM/16-bit (48kHz); Wave Format Base (AVI Motion JPEG)

Playback monitor

Type Tiltable LCD
Dimensions 3in (7.6cm)
Resolution 460,000 pixels
Coverage 100%
Languages English; French; German; Spanish; Italian; Russian; Czech; Dutch; Danish; Polish; Portuguese; Swedish; Norwegian; Finnish; Croatian; Slovenian; Hungarian; Greek; Slovak; Turkish; Latvian; Estonian; Lithuanian; Ukrainian; Serbian
Live View 100% field of view; Shooting information; Histogram; Face/Eye detection

Connections

External Interfaces USB 2.0; HDMI Type C mini connector; USB Video-out; Eye-Fi card compatible; Bluetooth compatible (with optional PENPAL adapter)
Other Flash hotshoe

Dimensions

Size 4.3 x 2.5 x 1.47in (109.5 x 63.7 x 37mm)
Weight 9.35oz (265g)

Included software

Olympus Viewer 2

Power

Rechargeable li-ion battery pack

» OLYMPUS E-PM1 Autumn 2011

OLYMPUS E-PM1 «
The E-PM1 is available in a variety of different color finishes.

With the release of the E-PM1 (or "Pen Mini") the digital PEN series now has a new, lower-priced entry level model. The design of the E-PM1 is far simpler than that of its two siblings, with dials stripped away in favor of a more menu-driven, point-and-shoot approach to using the camera.

As with the E-PL3, the E-PM1 includes Olympus's fast new AF system and TruePic VI image processor, making it a very well specified camera for its size. The design of the E-PM1 is obviously aimed at drawing photographers who would otherwise consider buying a compact digital camera: the lack of dials and buttons certainly makes the camera less intimidating when it is first picked up.

To further appeal to the entry-level market, Olympus offers the E-PM1 in a variety of colors: black, white, silver, dark brown, purple, and silver rose. This matches the way in which compact digital cameras are often sold as fun, "lifestyle" devices.

Live Guide

To help you achieve the best results, the E-PM1 (along with the E-P3 and E-PL3) has a feature dubbed Live Guide. This allows you to see immediately on the LCD what needs to be adjusted to achieve the results you desire, with immediate feedback as you make the changes.

Changes that can be made include the color intensity, image brightness, and the sharpness of the picture. These changes can all be achieved manually by more experienced photographers, but Live Guide's aim is to help novice photographers achieve professional-looking results both quickly and painlessly.

DEPTH OF FIELD »

Live Guide can help you achieve professional-looking results, but it should only be seen a bridge to understanding how your camera works. For this image I used a lens with a wide aperture setting and focused precisely to achieve the effect I wanted.

Settings
> Focal length: 45mm
> Aperture: f/2.8
> Shutter speed: 1/160 sec.
> ISO 400

Sensor
Resolution 12.3 megapixels (effective)
Type 4:3 aspect ratio High Speed Live MOS sensor

Image processor
TruePic VI

Body
Construction Materials Metal
Lens Mount Micro Four Thirds

Image sizes
Maximum 4032 x 3024 pixels
Minimum 1024 x 768 pixels

Storage media
SD Memory Card (SD/SDHC/SDXC)

File formats
Still Images JPEG (Fine; Normal); Raw (12-bit); Raw + JPEG; MPO (3D)
Movie Mode AVI Motion JPEG; AVHCD

Focus
Type High-speed contrast-detection AF
Modes Single AF; Continuous AF; Manual Focus; Single AF+MF; AF Tracking; Face detection
Focus Areas 35 points (Automatic and Manual selection)
Focus Selection Automatic; Manual
Depth of Field Preview No

Exposure
Metering Type TTL 324-zone multipattern
Metering Modes ESP light metering; Center-weighted; Spot (approx. 2%); Highlight Spot; Shadow Spot
Exposure Modes i-Auto; Program AE (**P**); Aperture Priority (**A**); Shutter Priority (**S**); Manual (**M**); Multi exposure
Scene Modes Portrait, e-Portrait, Landscape, Landscape with Portrait, Macro, Sports, Night Scene, Night Scene with portrait, Children, High key, Low key, Digital Image Stabilization, Nature Macro, Candle, Sunset, Documents, Panorama, Fireworks, Beach and Snow, Fisheye converter, Macro converter, 3D
Art Filters Pop Art, Soft Focus, Grainy Film, Pinhole, Diorama, Dramatic Tone
ISO Modes Auto/Manual
ISO Range 200–12,800
Exposure Compensation ±3 EV in ⅓, ½, or 1EV steps
Exposure Bracketing 2, 3, or 5 frames in ±⅓, ⅔, or 1EV steps; 7 frames in ⅓, ½, or ⅔EV steps
ISO Bracketing 5 frames in ± ⅓, ½, or 1EV steps

Shutter
Type Computerized focal-plane shutter
Shutter Speed 60 seconds–1/4000 sec.; Up to 30 minutes (Bulb); Multi-exposure

Image stabilizer
Type Sensor shift (still image); Digital shift (movie mode)

Viewfinder

Type Optional externally fitted VF-2 electronic viewfinder
Coverage 100%
Magnification x1.15
Eyepoint Approx. 18mm
Diopter Adjustment -3.0 to +1

Drive system

Modes Single; Sequential Shooting
Max. Frame Rate 4.1fps (5.5fps when IS is switched off)
Self Timer 2 seconds; 12 seconds

Flash

Built-in Flash No (external flash supplied)
Guide Number 33ft/10m at ISO 200
Flash Modes Auto; Manual; Red-eye Reduction; Red-eye Reduction Slow Sync; Slow Sync. 2nd Curtain; Fill-in; Off
Sync Speed 1/160 sec.
Flash Exposure Compensation ±3 EV in ⅓, ½, or 1EV steps

Movie recording

Recording Format AVI Motion JPEG; AVHCD
Modes Full HD 1920 x 1080 (60i); HD 1280 x 720 (60p); HD 1280 x 720 / 30fps (AVI Motion JPEG); SD 640 x 480 (AVI Motion JPEG)
Maximum Recording Time 29 minutes (AVHCD); 14 minutes (SD); 7 minutes (HD/ AVI Motion JPEG)
Sound Stereo PCM/16-bit (48kHz); Wave Format Base (AVI Motion JPEG)

Playback monitor

Type LCD
Dimensions 3in (7.6cm)
Resolution 460,000 pixels
Coverage 100%
Languages English; French; German; Spanish; Italian; Russian; Czech; Dutch; Danish; Polish; Portuguese; Swedish; Norwegian; Finnish; Croatian; Slovenian; Hungarian; Greek; Slovak; Turkish; Latvian; Estonian; Lithuanian; Ukrainian; Serbian
Live View 100% field of view; Shooting information; Histogram; Face/Eye detection

Connections

External Interfaces USB 2.0; HDMI Type C mini connector; USB Video-out; Eye-Fi card compatible; Bluetooth compatible (with optional PENPAL adapter)
Other Flash Hot Shoe

Dimensions

Size 4.3 x 2.5 x 1.34in (109.5 x 63.7 x 34mm)
Weight 7.6oz (216g)

Included software

Olympus Viewer 2

Power

Rechargeable li-ion battery pack

» USEFUL WEB SITES

CAMERA MANUFACTURERS

Olympus
www.olympus.com

Panasonic
www.panasonic.net

Leica
www.leica-camera.com

LENS MANUFACTURERS

Sigma
www.sigmaphoto.com

Lensbaby
www.lensbaby.com

Voigtländer
www.voigtlander.de

COMPUTER EQUIPMENT

Adobe
Photographic editing software such
as Photoshop and Lightroom
www.adobe.com

Apple
Hardware and software manufacturer
www.apple.com

GENERAL

David Taylor
Landscape and travel photography
www.davidtaylorphotography.co.uk

Four Thirds
Website dedicated to the Four Thirds system
www.four-thirds.org

Digital Photography Review
Camera and lens review site
www.dpreview.com

Photonet
Photography Discussion Forum
www.photo.net

PHOTOGRAPHY PUBLICATIONS

**Photography books &
Expanded Camera Guides**
www.ammonitepress.com

Black and White Photography magazine
Outdoor Photography magazine
www.thegmcgroup.com

» INDEX